Whistler
Blackcomb

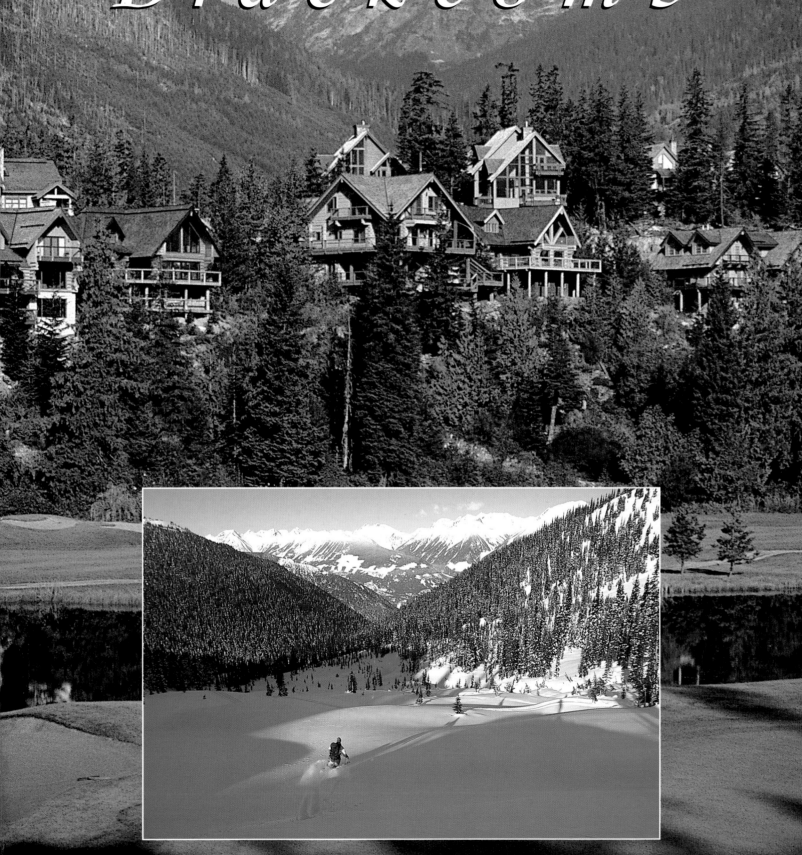

MW00964481

Whistler Village, nestled at the base of Whistler and Blackcomb mountains at the western edge of Garibaldi Park, offers startling contrast to the vast wilderness that surrounds it. Built to an award-winning design and developed by the brightest architects, planners and landscape professionals in North America, the village serves as a permanent home to 7,000 people, and a favourite destination for a million skiers, hikers, mountain climbers and other visitors every year.

Officially incorporated in 1975 as the first resort municipality in BC, Whistler has grown to become one of the most popular summer and winter resorts on the international scene. Worldwide recognition has rated the Whistler–Blackcomb Resort as tops for terrain, skiing quality and resort experience, and the area is becoming a favourite summer destination as well. It is truly in a class by itself.

Whistler has always been a community founded on visions. When the first non-Native settlers arrived in the nineteenth century, they walked along trails that the Squamish and neighbouring St'at'imc people had used as trade routes for millennia, and they called their settlement Alta Lake, for the lake at the highest elevation in the area. The railway to Howe Sound was twenty-five years in the future and the road was sixty-five years away, yet the pioneers knew their new home was special enough to attract admiring visitors from all over the world.

They were right. By 1910 the Whistler area was already a favourite destination of intrepid mountain climbers. They came here to experience Blackcomb and "London Mountain"—which soon became known as Whistler, for the high-pitched cry of the marmots that live on the mountain. Myrtle and Alex Philip came to Alta Lake in 1911, lured by tales of wild beauty that turned out to be entirely true. When they laid the log foundation of Rainbow Lodge on the shore of the lake in 1913, they could not know that the lodge would exceed their wildest dreams—that fishermen, honeymooners and adventurers would stream through their doors for the next thirty years, and that the Rainbow Lodge would grow to become the most popular summer resort west of the Rockies.

That same kind of vision inspired Franz Wilhelmsen and a group of Vancouver businessmen to install the first ski lifts on the flanks of Whistler Mountain in 1966. Despite numerous warnings that Whistler would never succeed as a ski resort, the directors of Garibaldi Lift Company, as it was known then, stayed with their dreams, and Whistler never looked back.

For people who love the outdoors, there could be no better companion for Whistler than Blackcomb Mountain. Local legend has it that Alex Philip, founder of the Rainbow Lodge, gazed across the landscape he loved one day and noticed that one of the peaks nearby looked like a rooster's comb, but black rather than red. Mountain climbers, rock climbers and skiers were regular visitors to Blackcomb by the 1920s. In the 1970s, when ski runs were established on Blackcomb and the north side of Whistler was developed further, one of the most exciting ski experiences in the world emerged—access to both mountains' deep powder bowls and long runs. Today, thousands of skiers and sightseers can be whisked up every hour in the latest high-speed lift systems, to enjoy hundreds of marked trails and a unique high alpine experience.

Whistler Resort is definitely a "people place." Attractive retail shops, cozy restaurants and lively night spots form the hub of the village. Accommodation ranges from family-style hotels to luxurious suites, spacious condominiums and charming lodges. The local conference centre boasts a ballroom and full facilities for conventions and trade shows.

The natural environment surrounding Whistler Village is perfectly suited to outdoor recreation and has been developed for year-round use. An elaborate multi-use trail system winds through the valley, linking its five lakes, numerous

Previous pages:
The Whistler Golf Club
looking towards
Blueberry Hill.
Photo: Ingrid Wypkema

Inset:
Heli-skiing on the
Pemberton Ice Cap.
Photo: Leanna Rathkelly

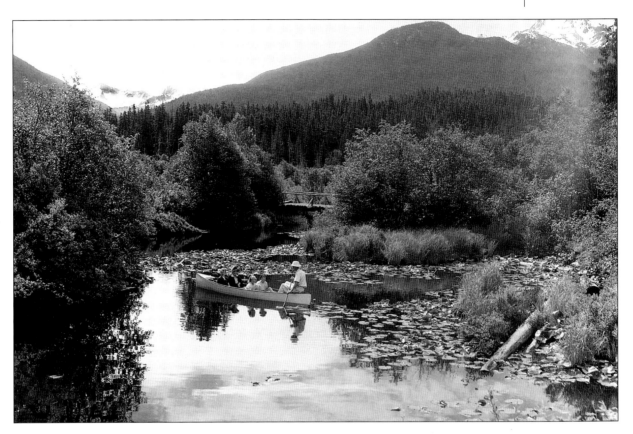

The River of Golden Dreams at Rainbow Lodge, Alta Lake, 1941. Although the Rainbow Lodge is no longer in operation, canoeing on the river is still a popular recreation activity.
VPL 15255

beaches, tennis courts, ball fields and picnic sites. In winter the trails offer superb cross-country skiing, and in summer walking, cycling and rollerblading take over. At Blackcomb, skiers can enjoy public summer skiing on prime springlike snow conditions, in comfortable temperatures, and popular summer ski camps offer top-level coaching for young and old alike. Both mountains run extensive summer hiking, sightseeing and mountain biking programs.

Whistler Village sets the stage from June through September with its Summer Festivals Program, a series of entertaining musical concerts and other performances. Summer also attracts golfers, who come to Whistler to play on the three 18-hole courses—the Arnold Palmer designed Whistler Golf Club adjacent to the village, the Robert Trent Jones designed Chateau Whistler Resort course across Fitzsimmons Creek and the new Nicklaus North course at the south end of Green Lake.

Summer skiing over crisp glaciers under blue skies, canoeing on the River of Golden Dreams, paragliding over the valley, horsepacking in the backcountry or simply relaxing in the splendid scenery—the Whistler–Blackcomb experience has something for everyone.

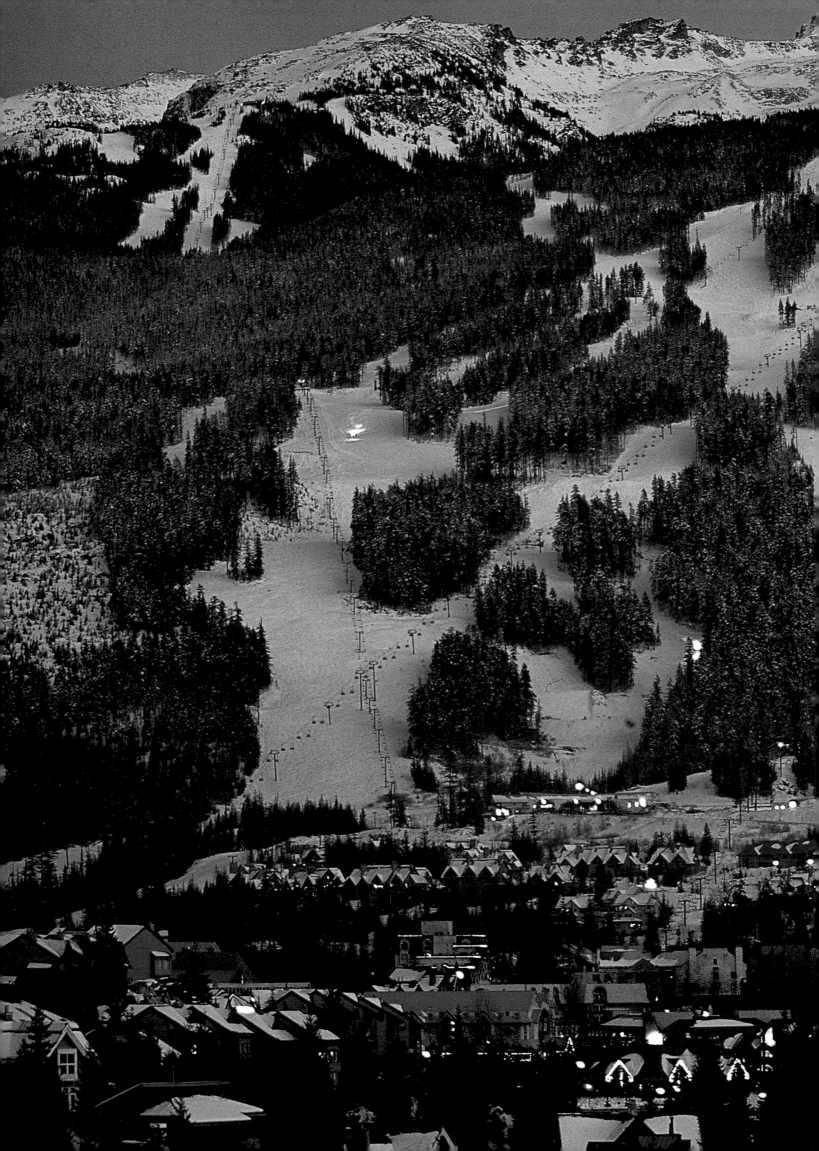

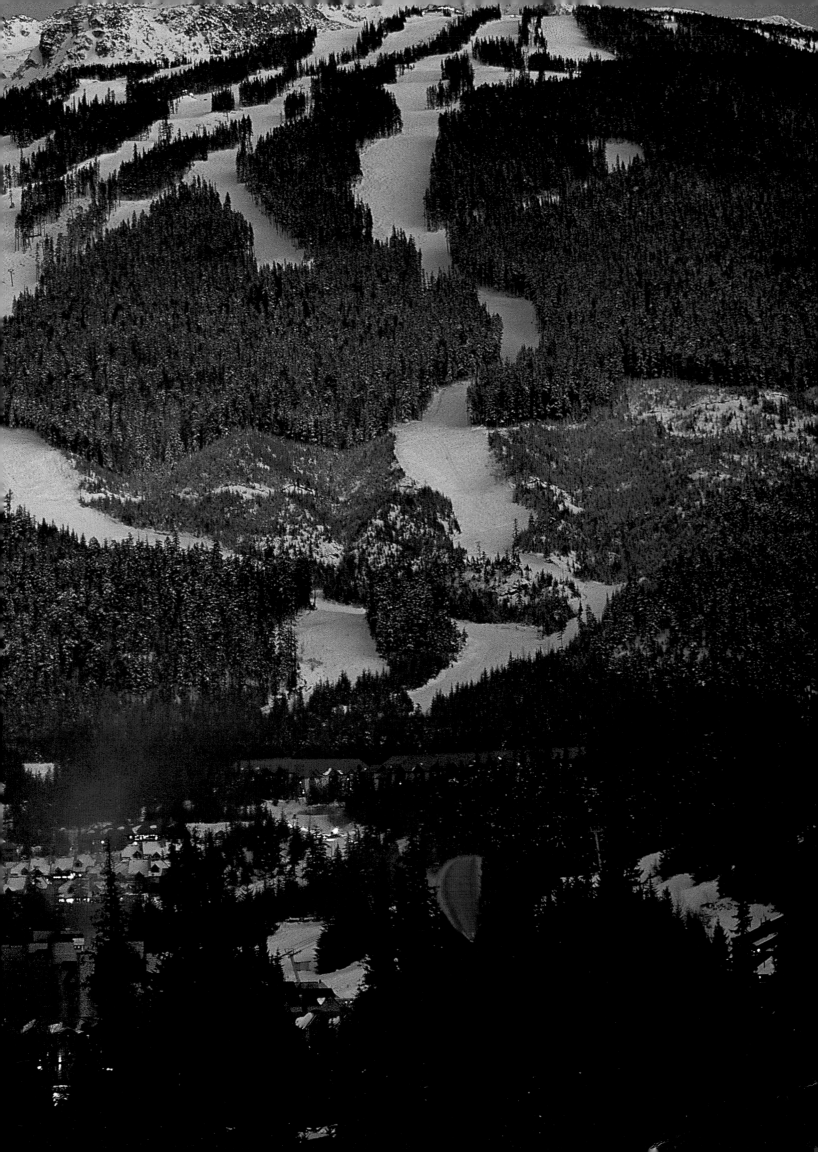

Previous pages:
Dusk falls on Whistler Village and towering Blackcomb
Mountain.
Photo: Greg Griffith

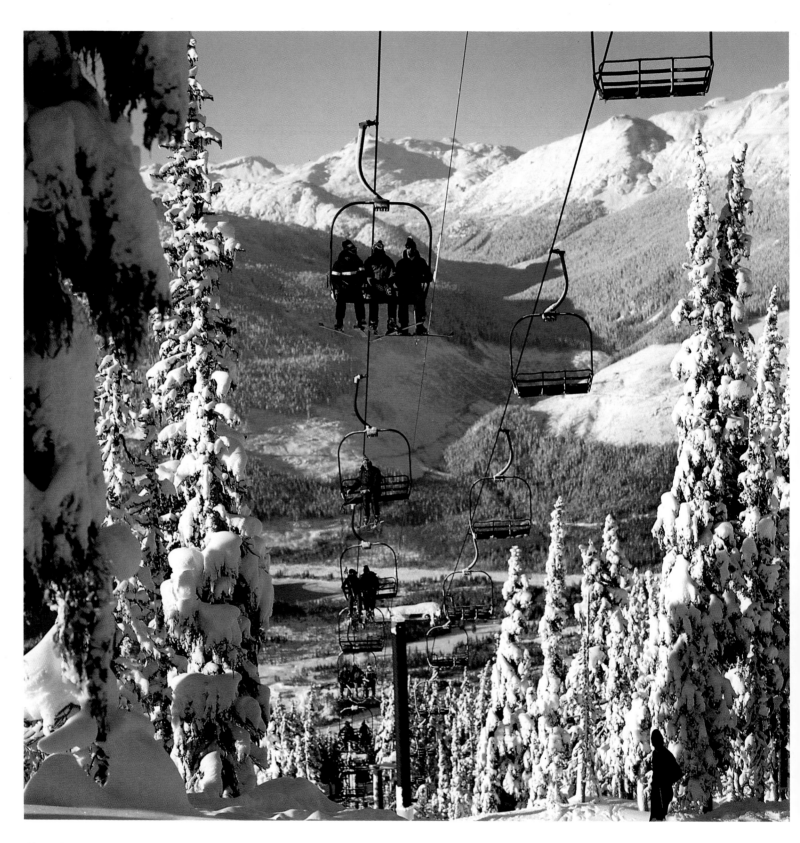

*Nature's magic is something to behold on
a snow-laden mountainside at Blackcomb.*
Photo: Greg Griffith

Whistler Express, a high-speed gondola, provides year-round access to Whistler Mountain's high alpine areas.
Photo: Greg Griffith

The seventh heaven express chairlift and Horstman Hut at the peak of Blackcomb Mountain.
Photo: C. Speedie-WRA

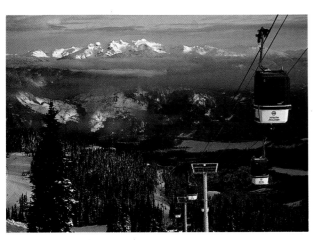

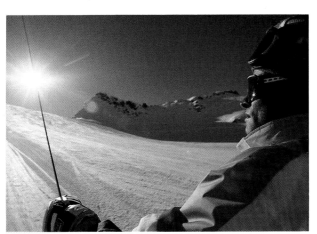

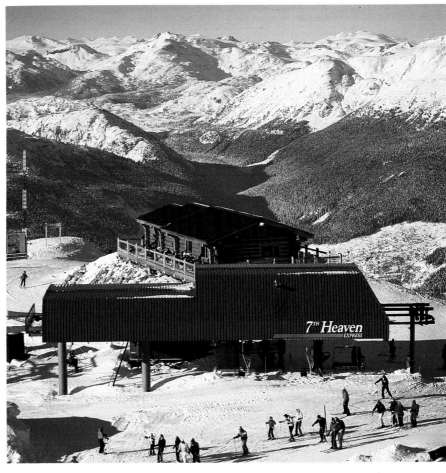

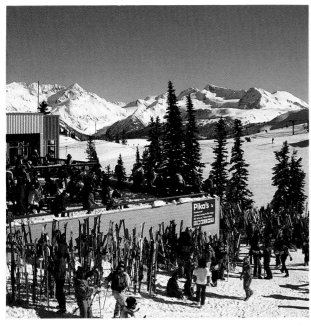

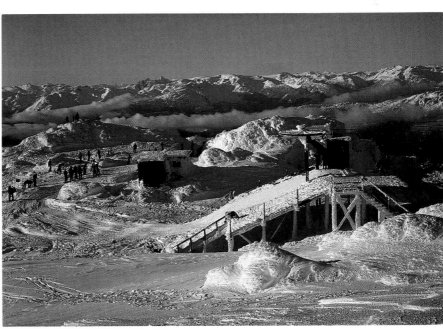

Middle:
Riding the T-Bar at Horstman Glacier on Blackcomb Mountain.
Photo: D. Stoecklein

Bottom:
Pika's, near the top of Whistler Mountain, a refreshing resting place to enjoy the splendid scenery.
Photo: Greg Griffith

Whistler's Peak Chair provides breathtaking views and access to unlimited skiing terrain.
Photo: Greg Griffith

*Thrills and chills abound at a snowboard event on
Whistler Mountain.*
Photo: Paul Morrison

*A speed skier dressed in high-tech gear prepares for
a high-speed run on Blackcomb Mountain.*
Photo: Paul Morrison

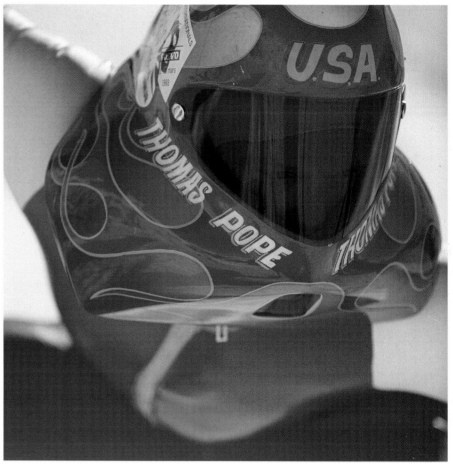

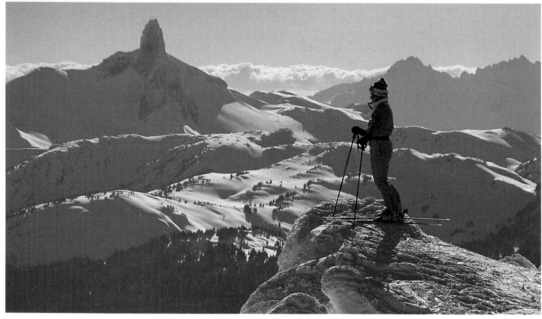

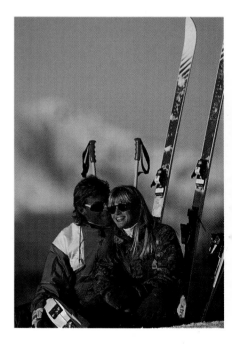

*A breathtaking view of Black Tusk from
Whistler Mountain.*
Photo: Paul Morrison

*After a sunny day's workout on the slopes,
ear-to-ear grins are a common occurrence.*
Photo: D. Stoecklein

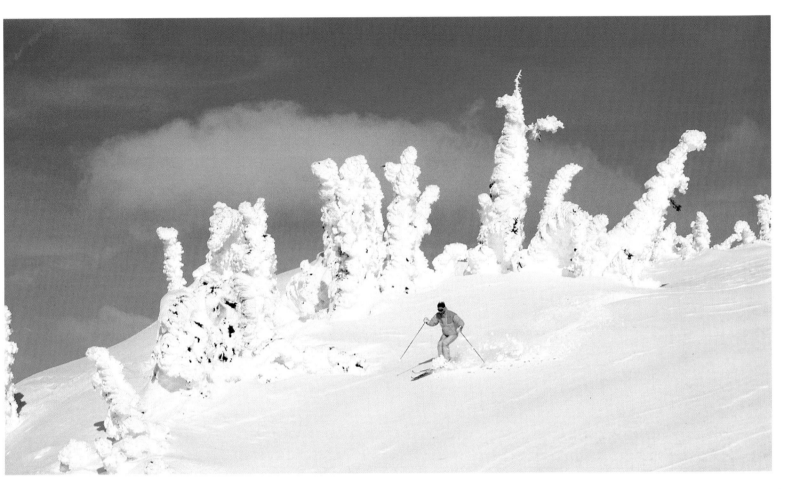

*Skiing alone past snow-encrusted trees is
one of life's special pleasures.
Photo: Greg Griffith*

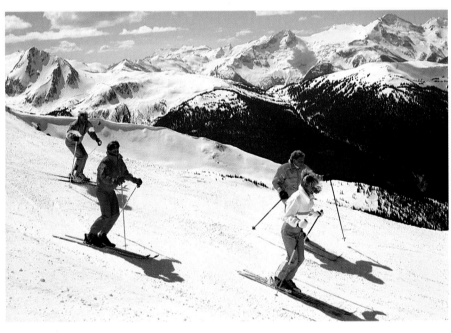

*Internationally, both mountains are rated tops for their skiing
quality and terrain extent.
Photo: C. Speedie-WRA*

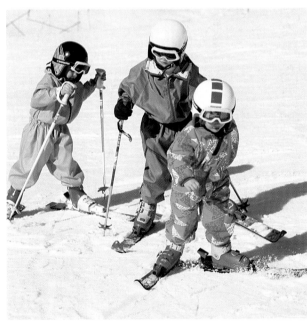

*Special programs for children of all ages are available on both
Whistler and Blackcomb Mountains.
Photo: D. Stoecklein*

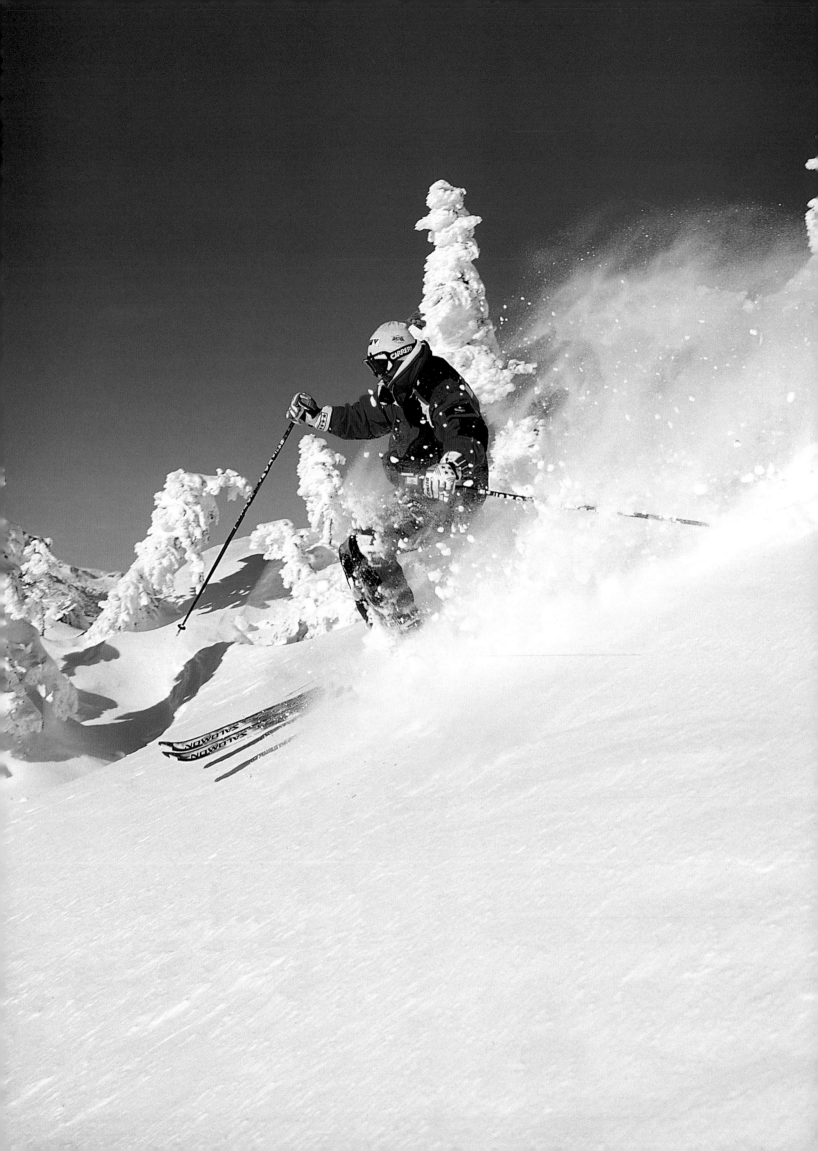

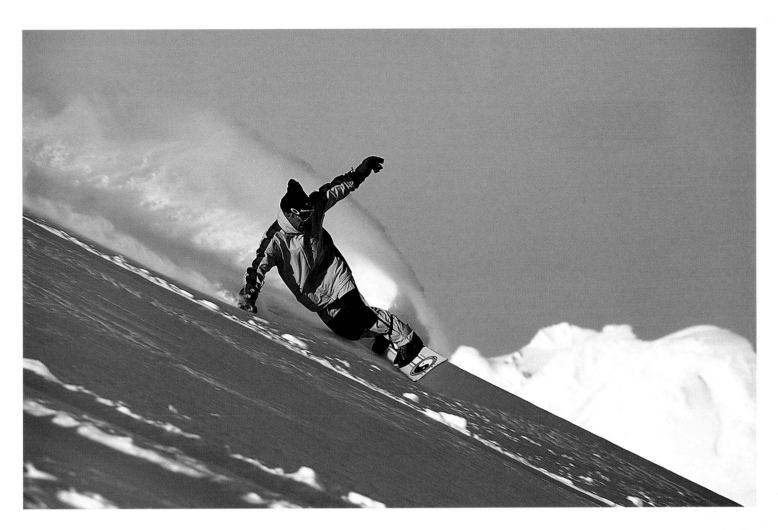

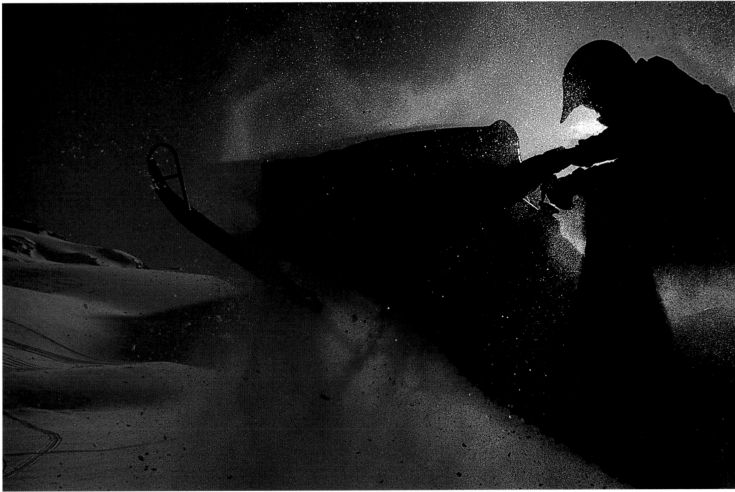

Opposite:
Skier on The Peak, Whistler Mountain.
Photo: Greg Griffith

Above:
Snowboarding on top of Blackcomb Mountain (photo: Greg Griffith);
snowmobiller Curtis Lawrence on Powder Mountain (photo: Maureen Provencal).

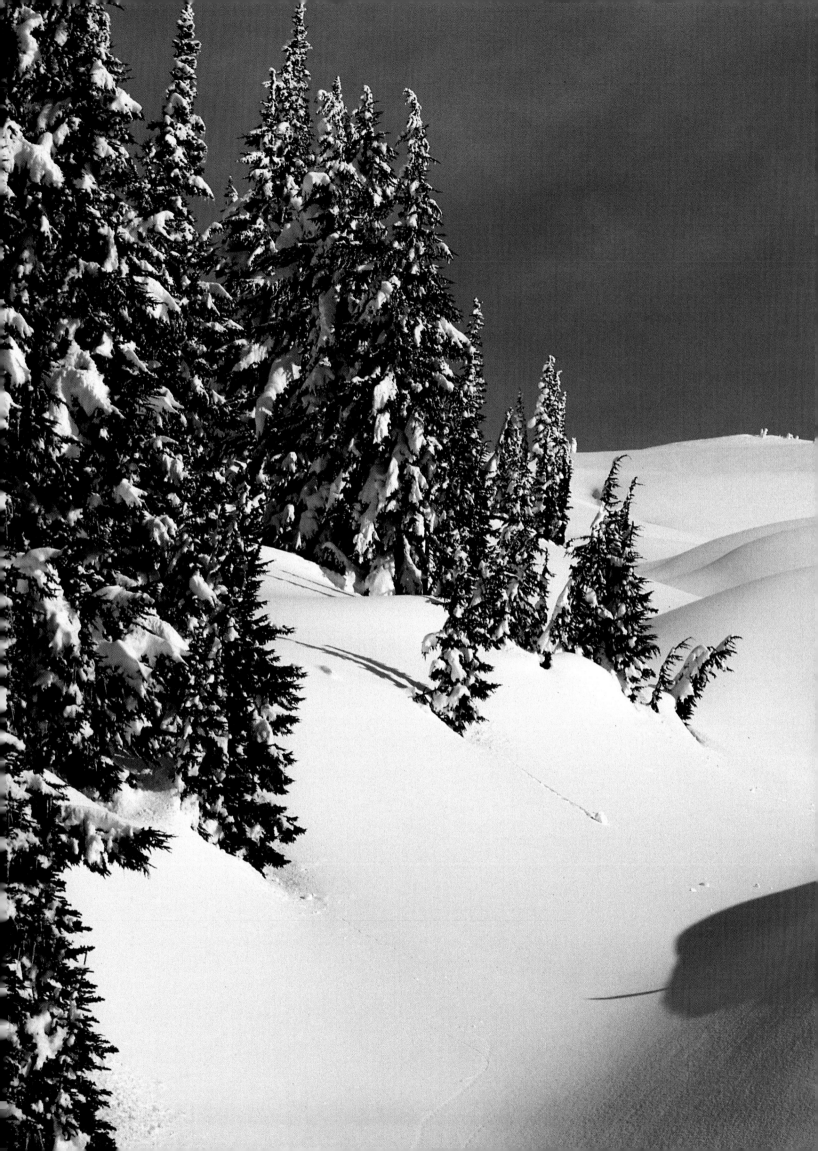

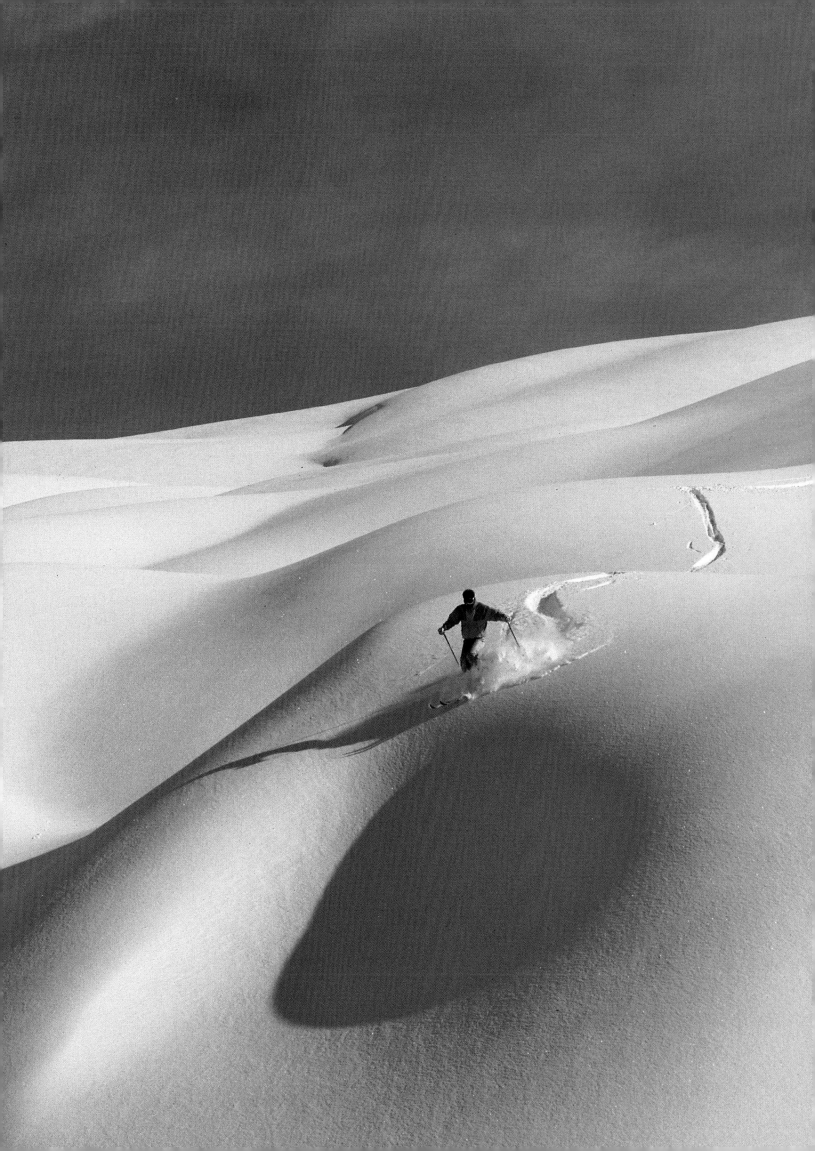

Previous pages: A lone skier enjoys the tranquility and fresh powder snow
on Whistler Mountain's back bowl.
Photo: Greg Griffith

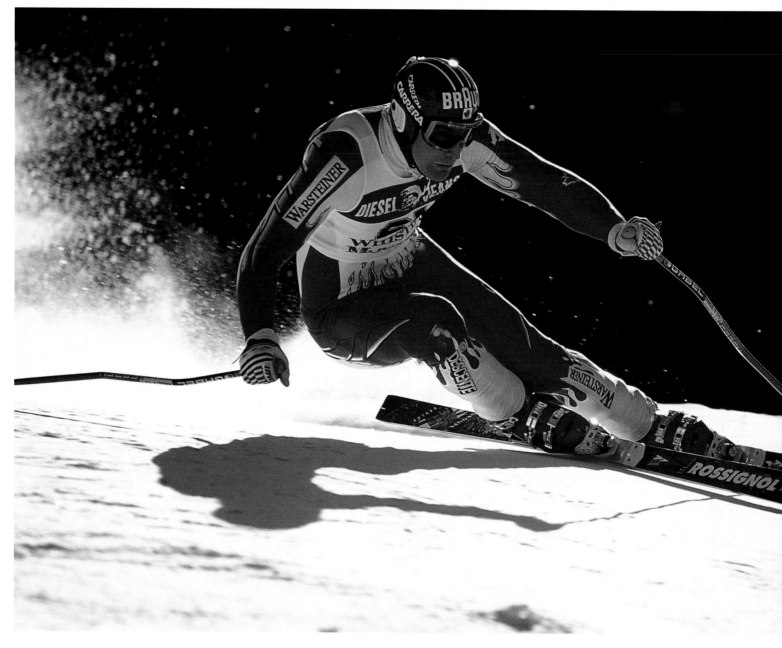

Above:
Edi Podivinski at the World
Cup Downhill Race.
Photo: Bonny Makarewicz

Right:
Whistler's Ross Rebagliati
competes in the Grand
Slalom event of the World
Cup Snowboard
championships.
Photo: Bonny Makarewicz

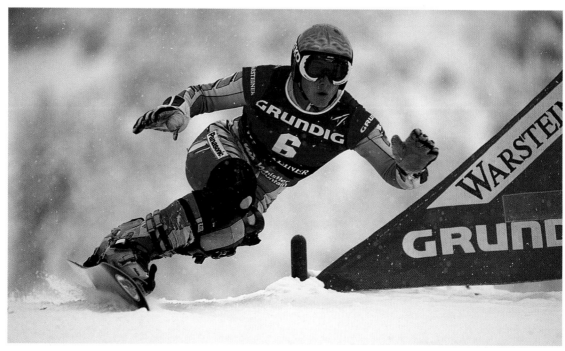

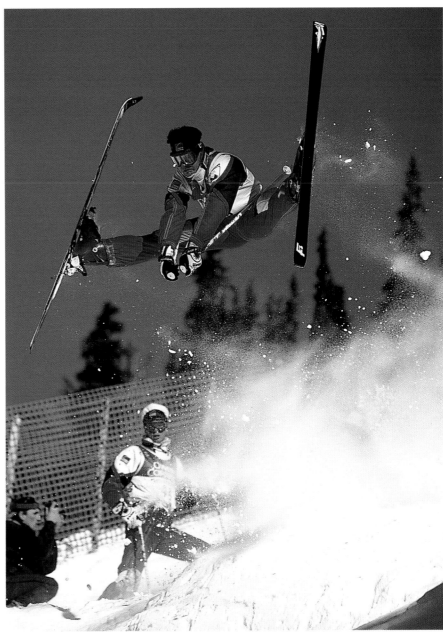

Above:
A participant takes to the air
in the Owen Corning Freestyle
Championships.
Photo: Bonny Makarewicz

Left:
Canada's Fred Lamothe
at the World Telemark
championships.
Photo: Bonny Makarewicz

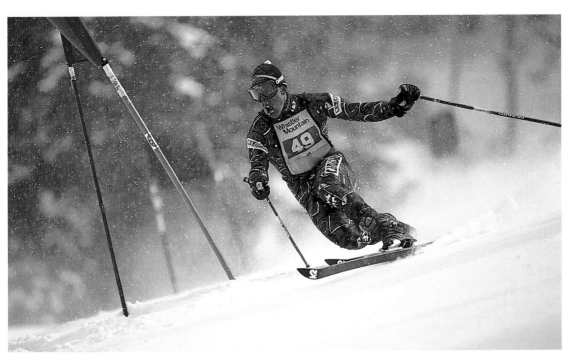

New Year's Eve celebrations at Whistler Village.
Photo: Paul Morrison

A relaxing and invigorating way to soothe the aches and pains of a day on the slopes.
Photo: A. Zenuk-WRA

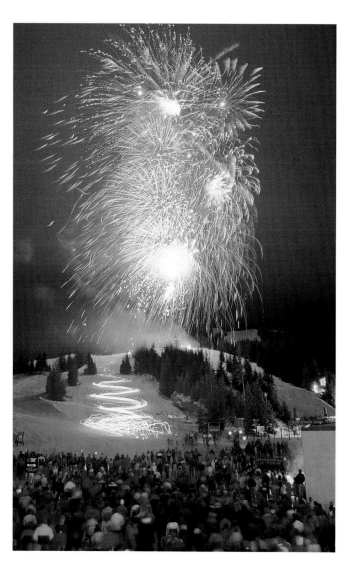

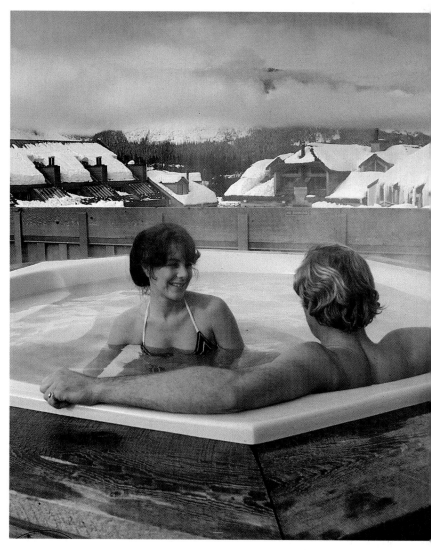

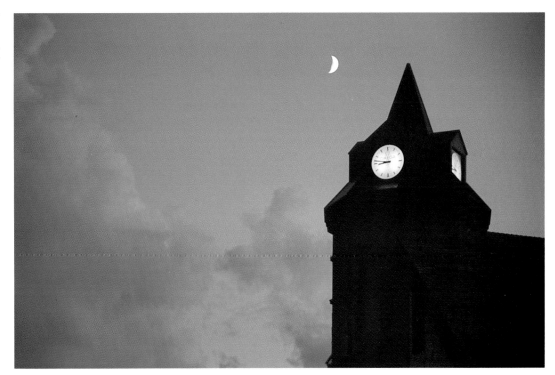

The evening cloud parts to reveal a quarter moon beyond the clock tower.
Photo: D. Sequin

After sunset, groomers prepare the ski runs for the next morning, while the town comes alive and bustles with night life.
Photo: Greg Griffith

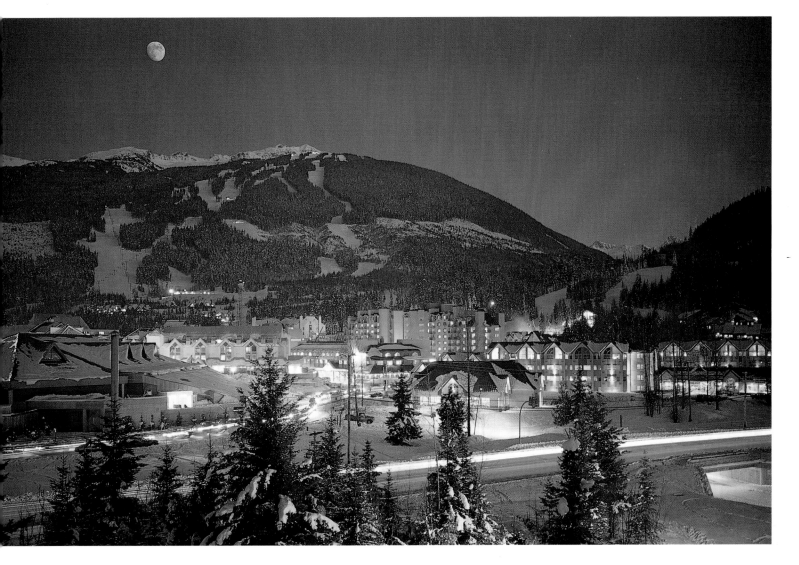

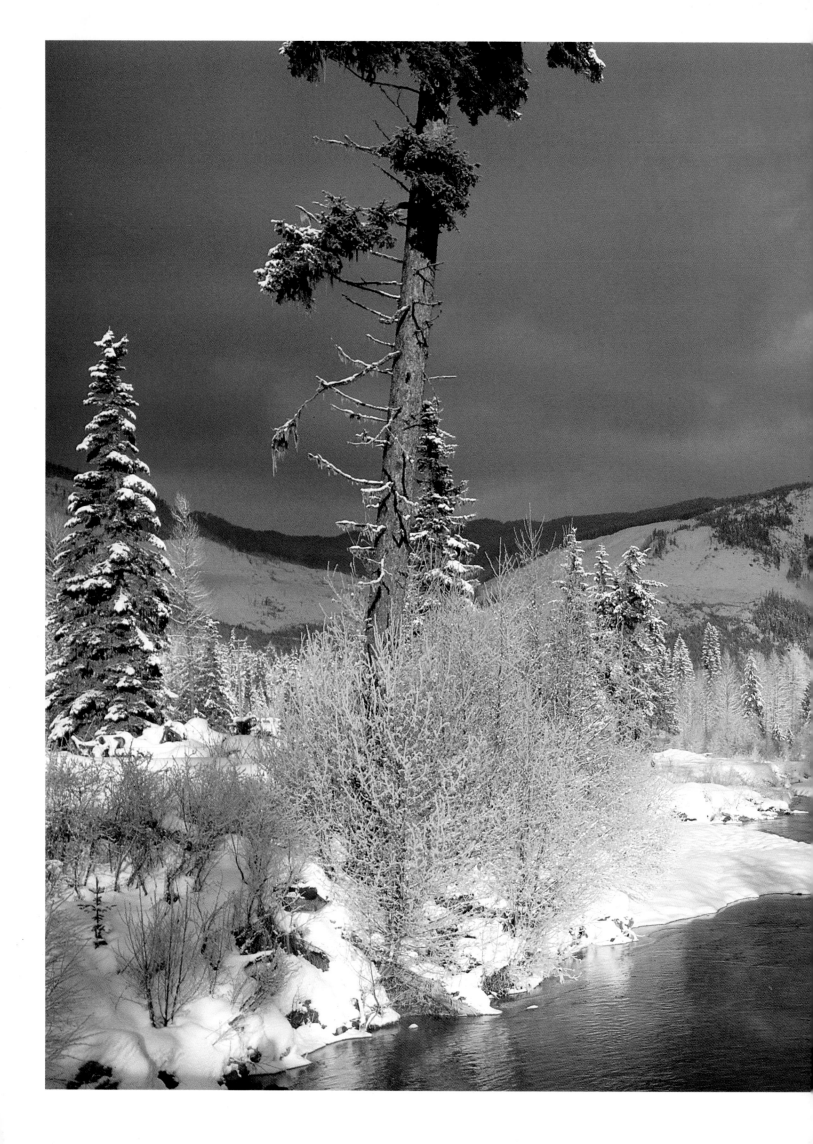

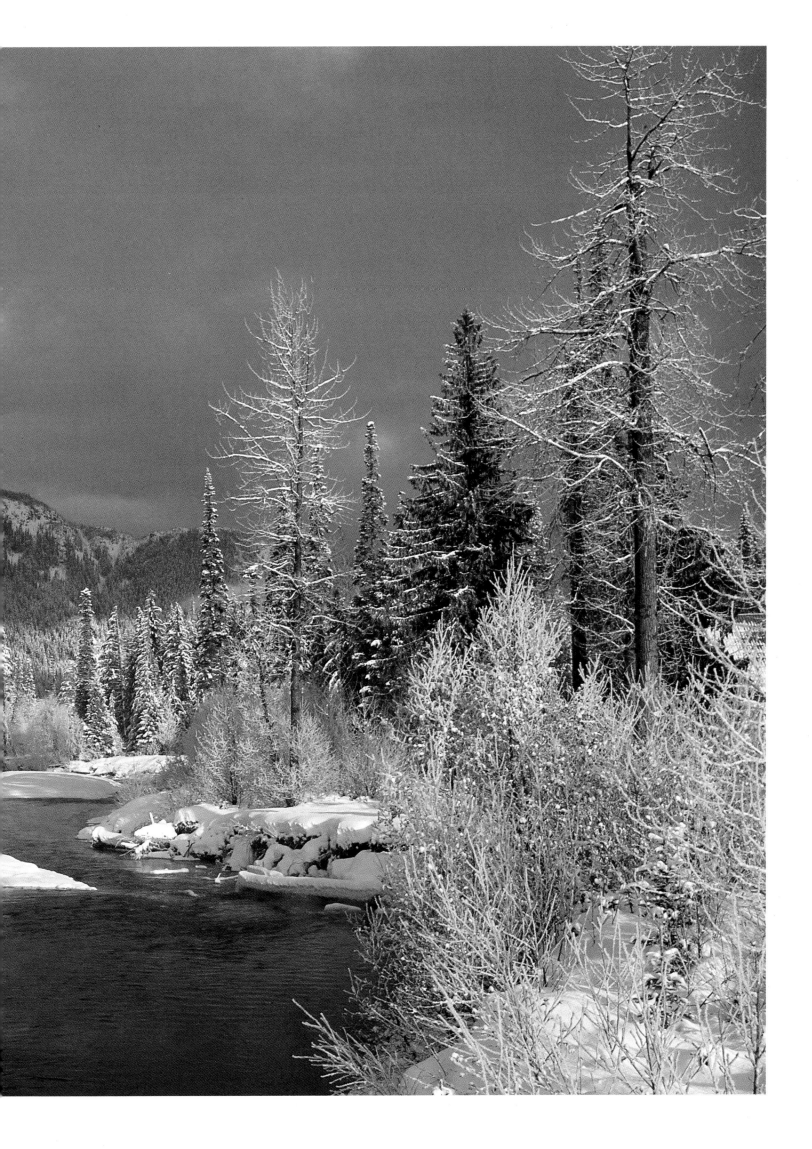

Previous pages: An early winter storm frosts the trees with a sparkling coat of wet snow.
Photo: Greg Griffith

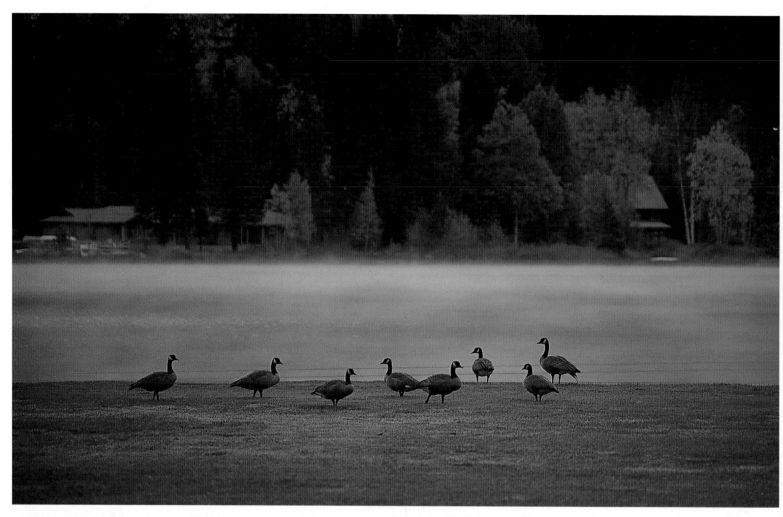

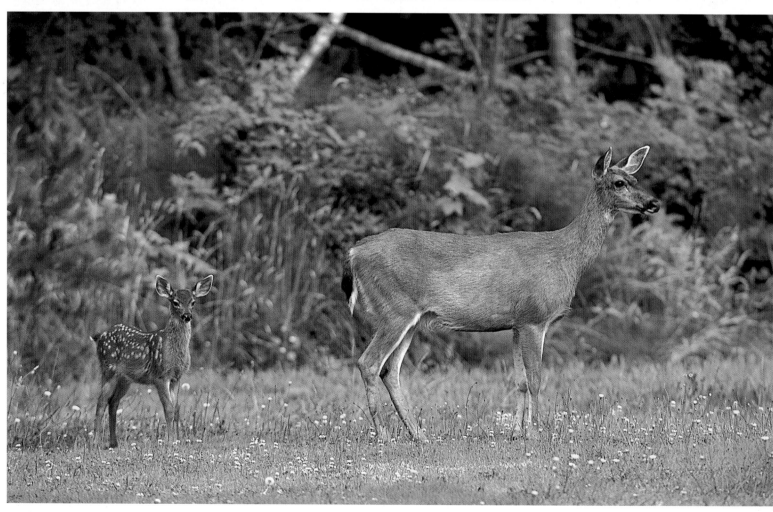

Opposite:
*Sunrise and Canada geese at Rainbow Park on Alta Lake;
a doe and her fawn graze along the roadside.*
Photos: Maureen Provencal

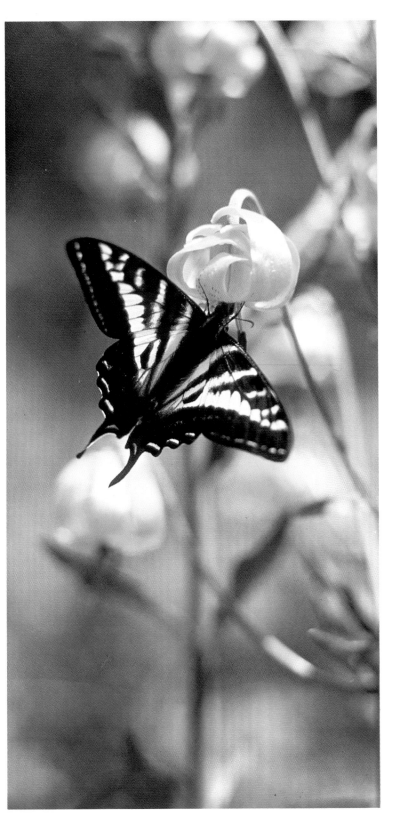

A swallowtail takes nectar from a wild tiger lily.
Photo: J. Pollack

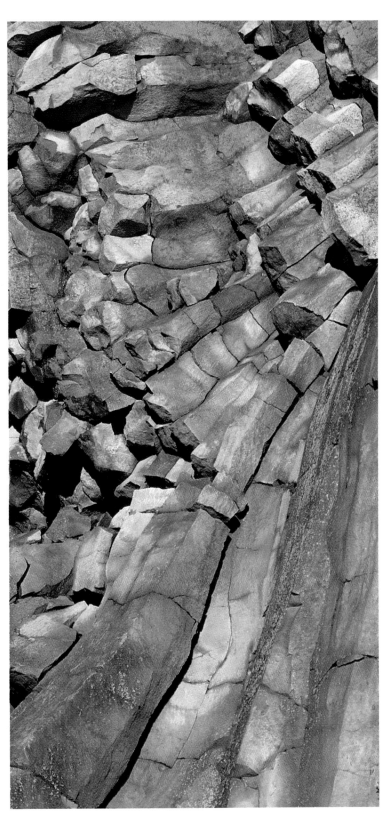

*Huge columns of basalt are all that remains of the last volcanic
activity near Whistler, which occurred thousands of years ago.*

The Arnold Palmer-designed Chateau Whistler Resort
golf course has gained a reputation as one of the most
scenic and challenging courses in Canada.
Photo: Greg Griffith

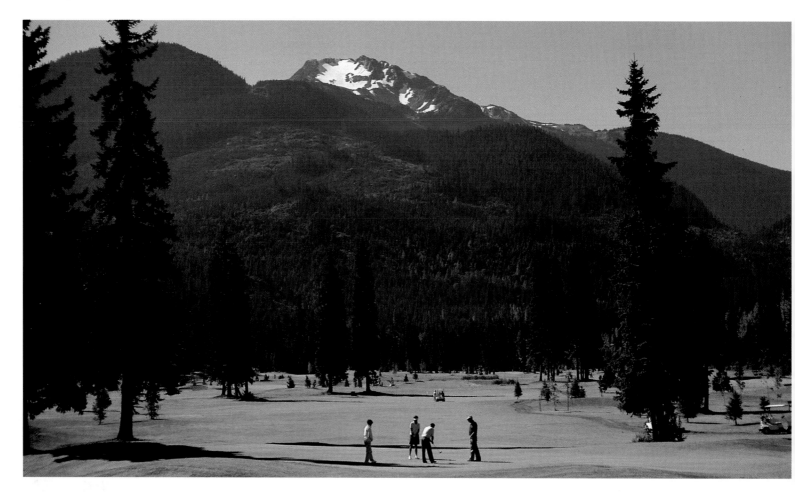

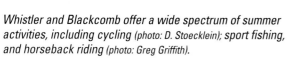

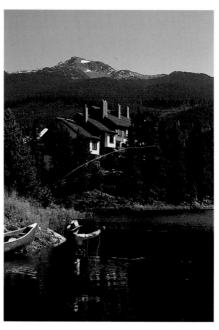

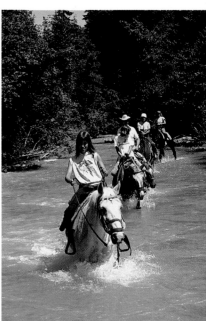

Whistler and Blackcomb offer a wide spectrum of summer
activities, including cycling (photo: D. Stoecklein); sport fishing,
and horseback riding (photo: Greg Griffith).

A network of trails links subdivisions, lakes, playgrounds, ballparks and beaches throughout the Whistler valley.
Photo: C. Speedie-WRA

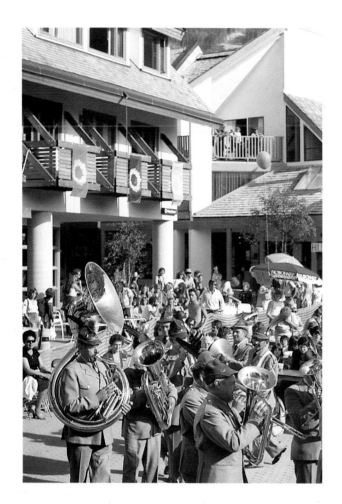

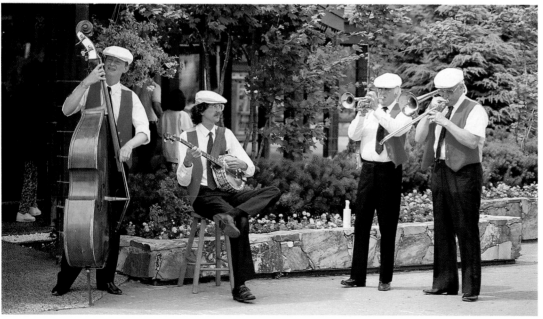

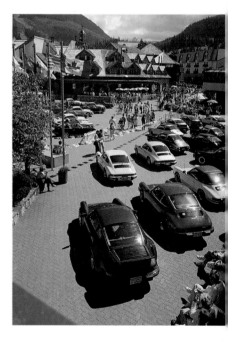

*In early summer, Whistler Resort sets the stage for a program
of concerts, festivals and street entertainers.*
*Photos: Leanna Rathkelly (top right and bottom right),
C. Speedie-WRA (bottom left).*

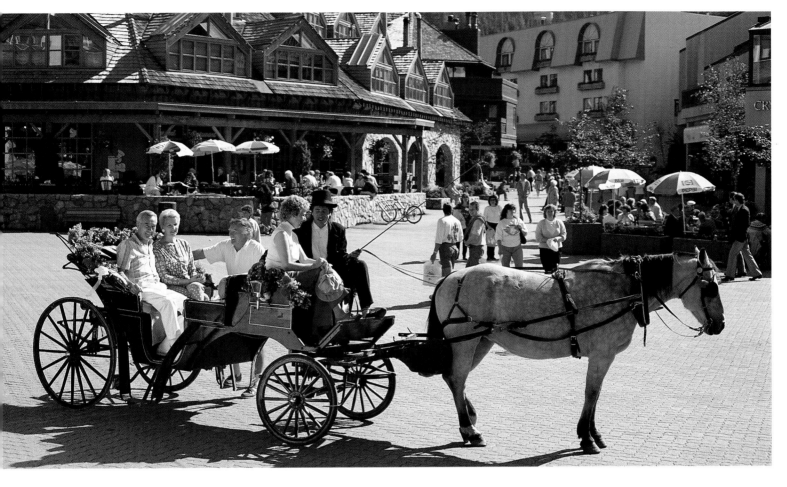

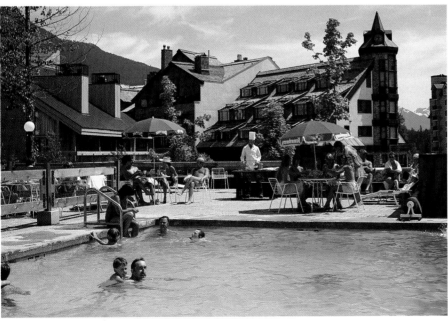

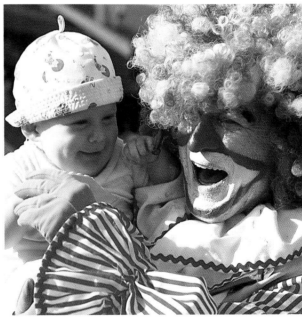

For young and old, the simplest entertainment can be the most fun.
Photos: C. Speedie (top), Greg Griffith (bottom left).

The Whistler Conference Centre is a 9,000-square-metre, state-of-the-art facility that hosts a variety of functions and handles groups of up to 1,800 people.
Photos (clockwise from top left): Leanna Rathkelly, C. Speedie-Blackcomb Mountain, Joseph King.

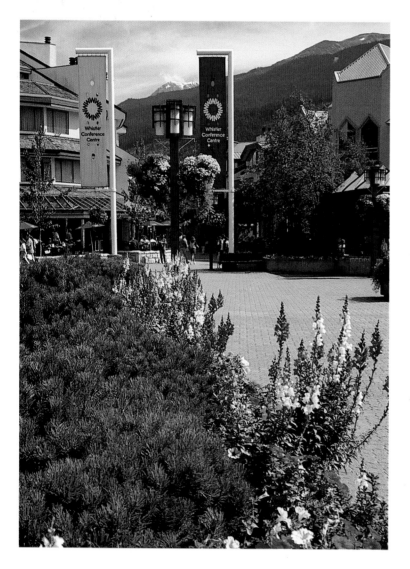

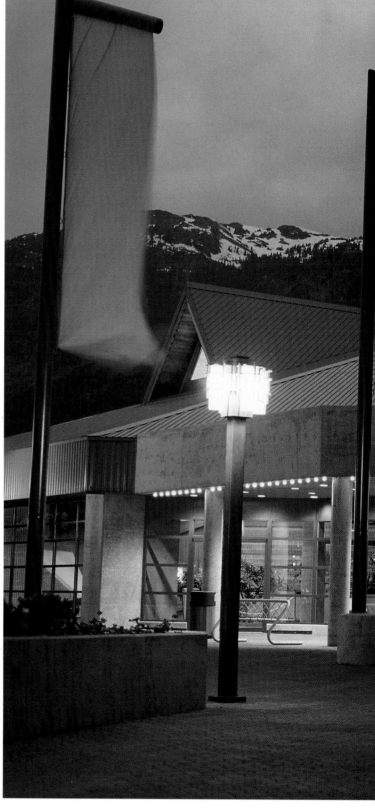

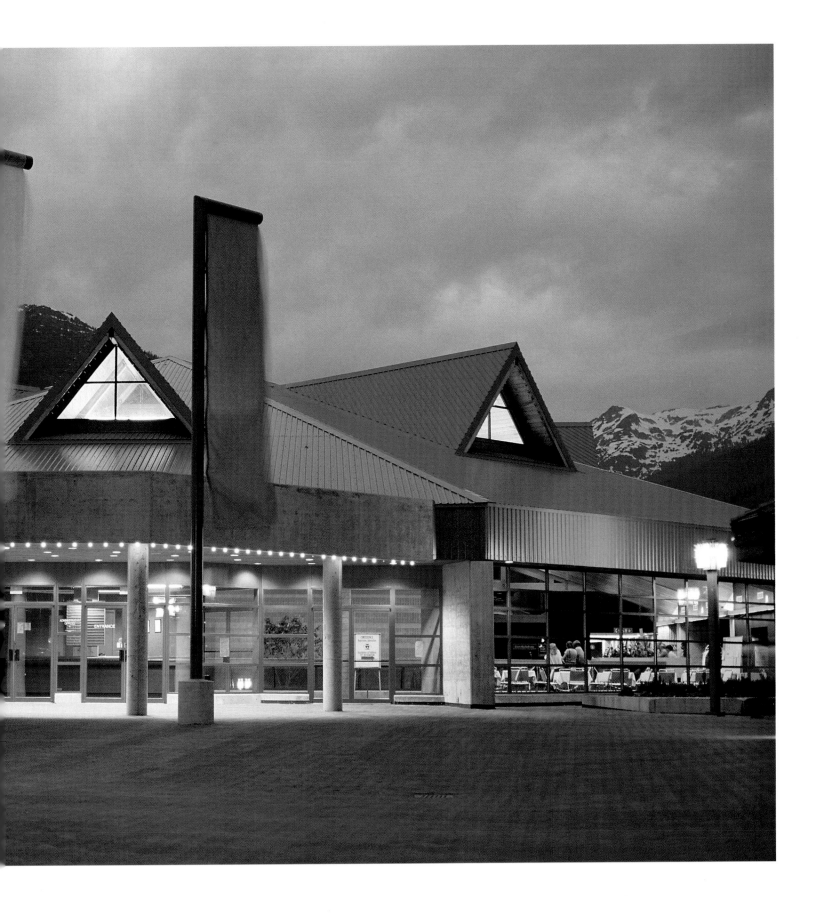

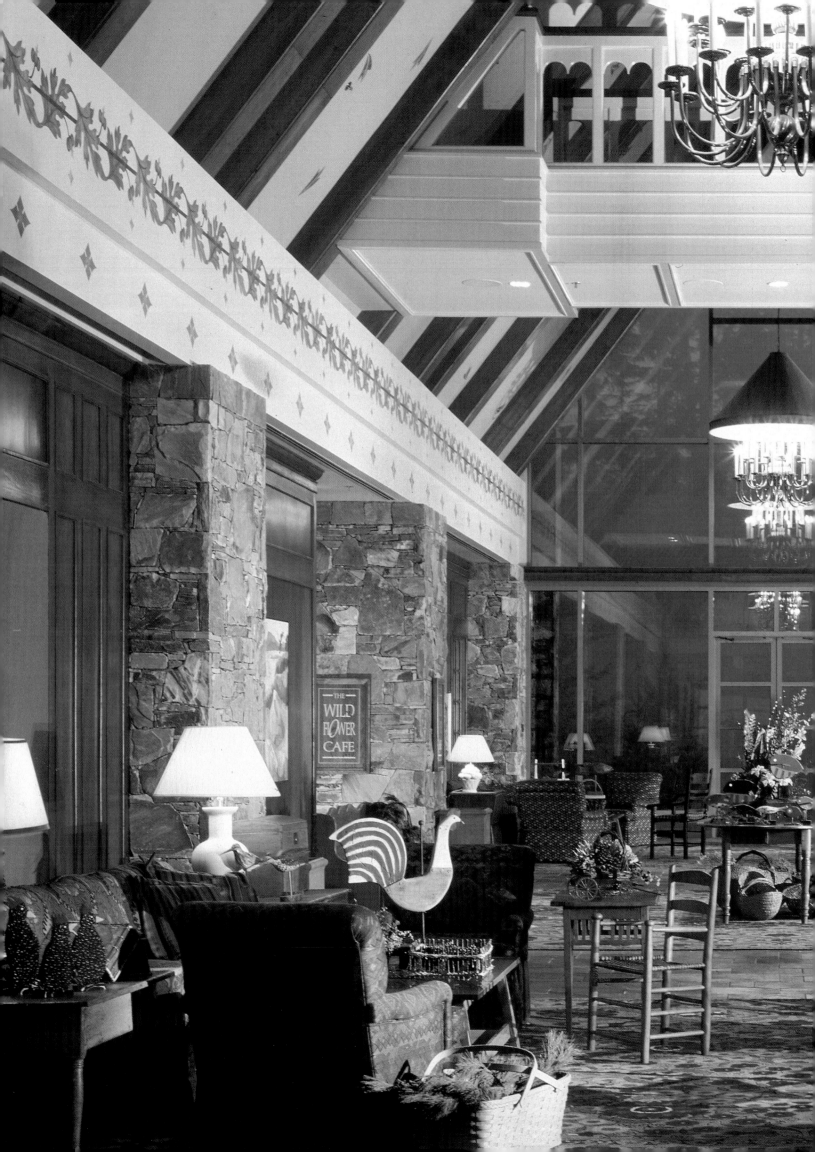

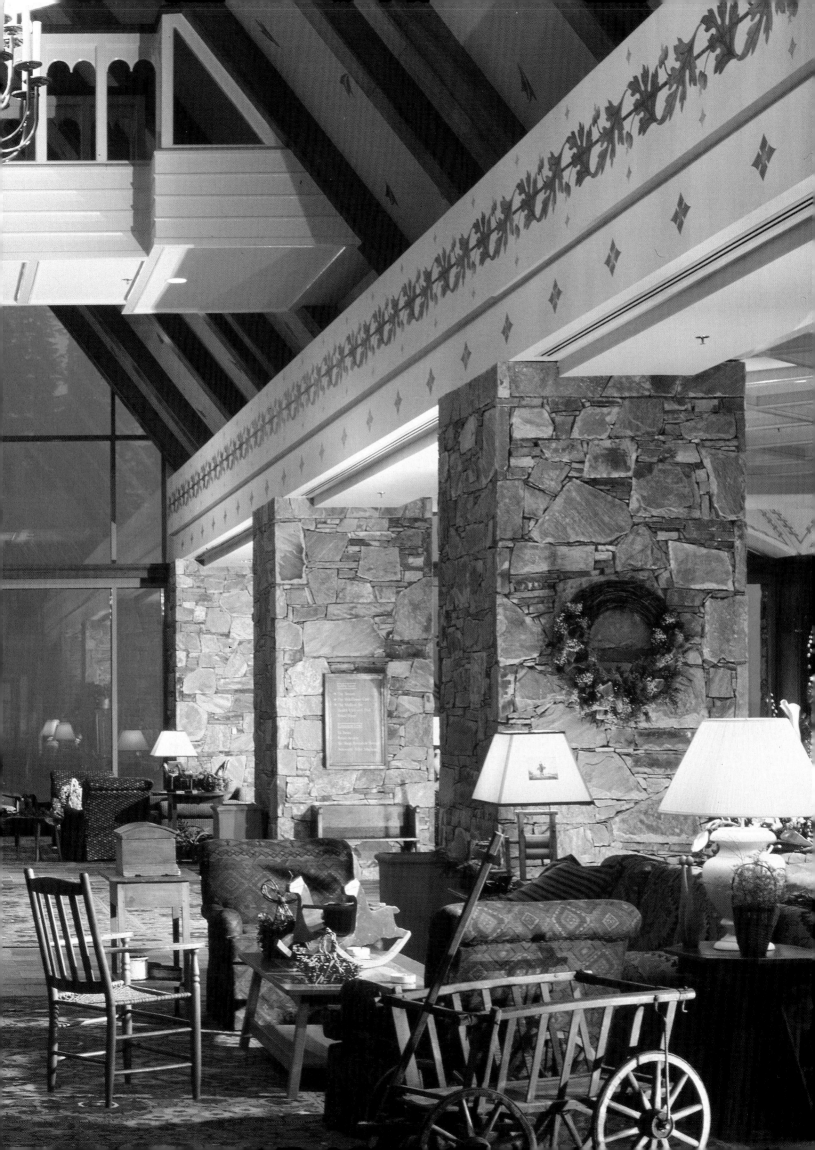

Previous pages:
The Great Hall in the entrance and lobby of Chateau
Whistler, a superb architectural creation blending
traditional styles, modern materials and folk art.
Photo: M. Nichols

Opposite:
Whistler Village now attracts as many visitors
in the summer as in the winter.
Photo: M. Nichols

Chateau Whistler is the area's leading hotel.
Photo: M. Nichols

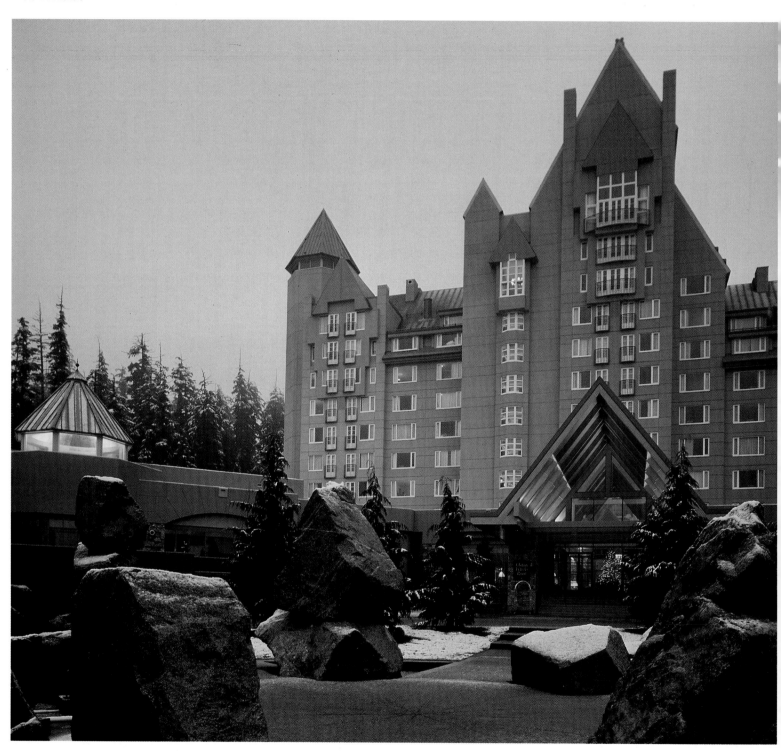

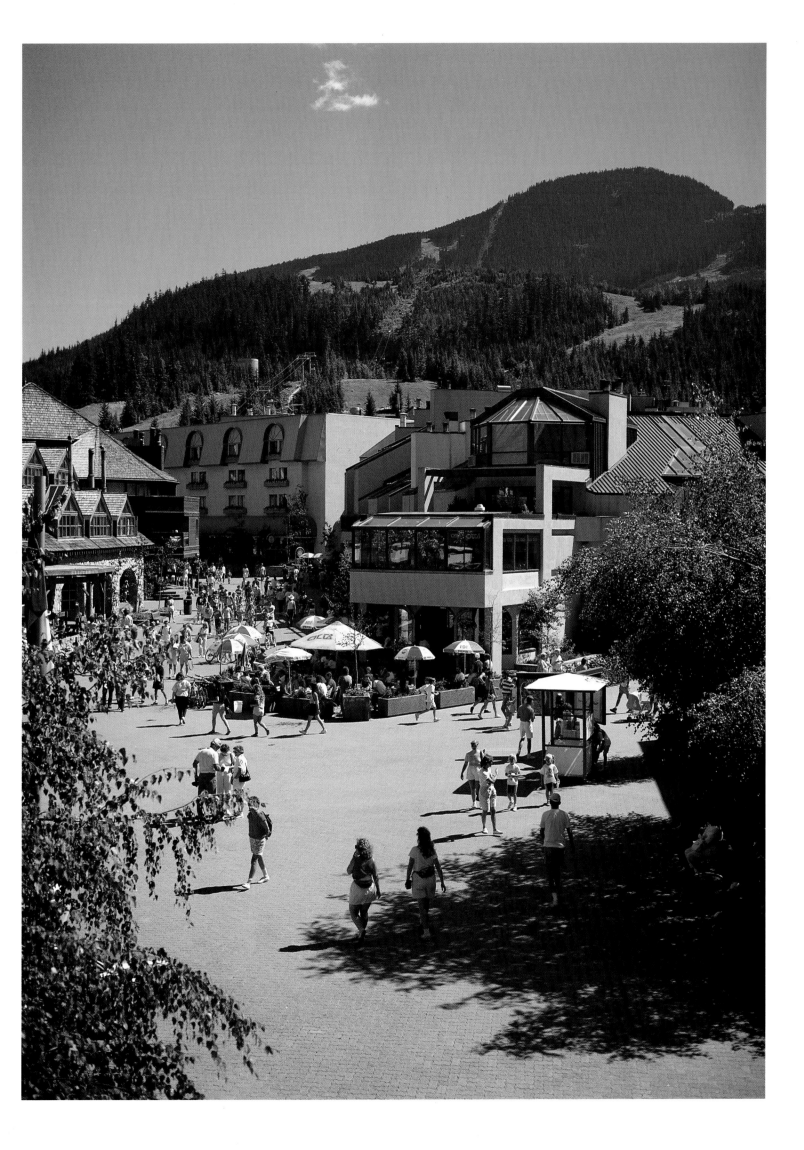

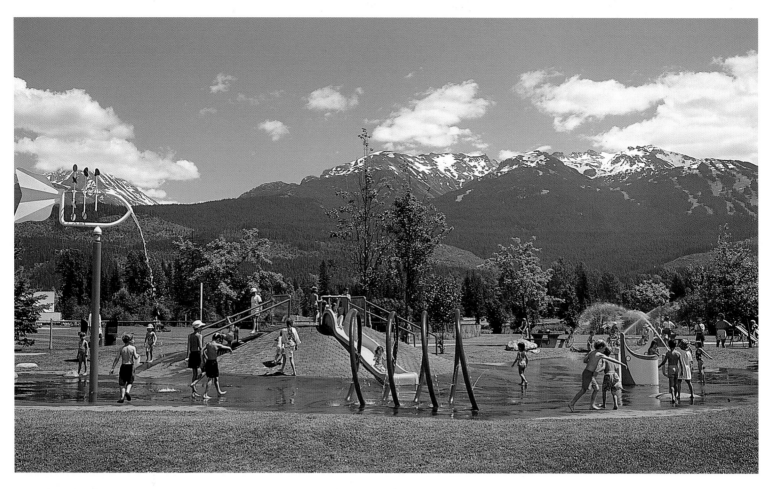

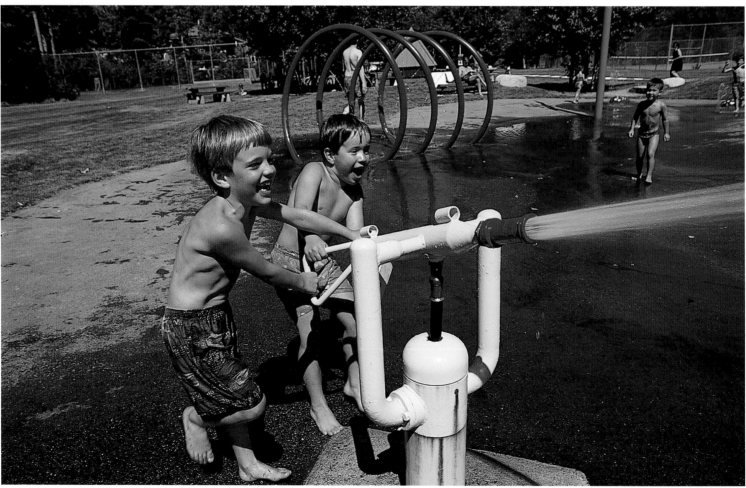

The Meadow Water Park at Whistler is
a popular summer play area.
Photos: Leanna Rathkelly

Opposite:
The climbing wall at Whistler Village is open
to the public during the summer.
Photo: Greg Eymundson/INSIGHT PHOTO

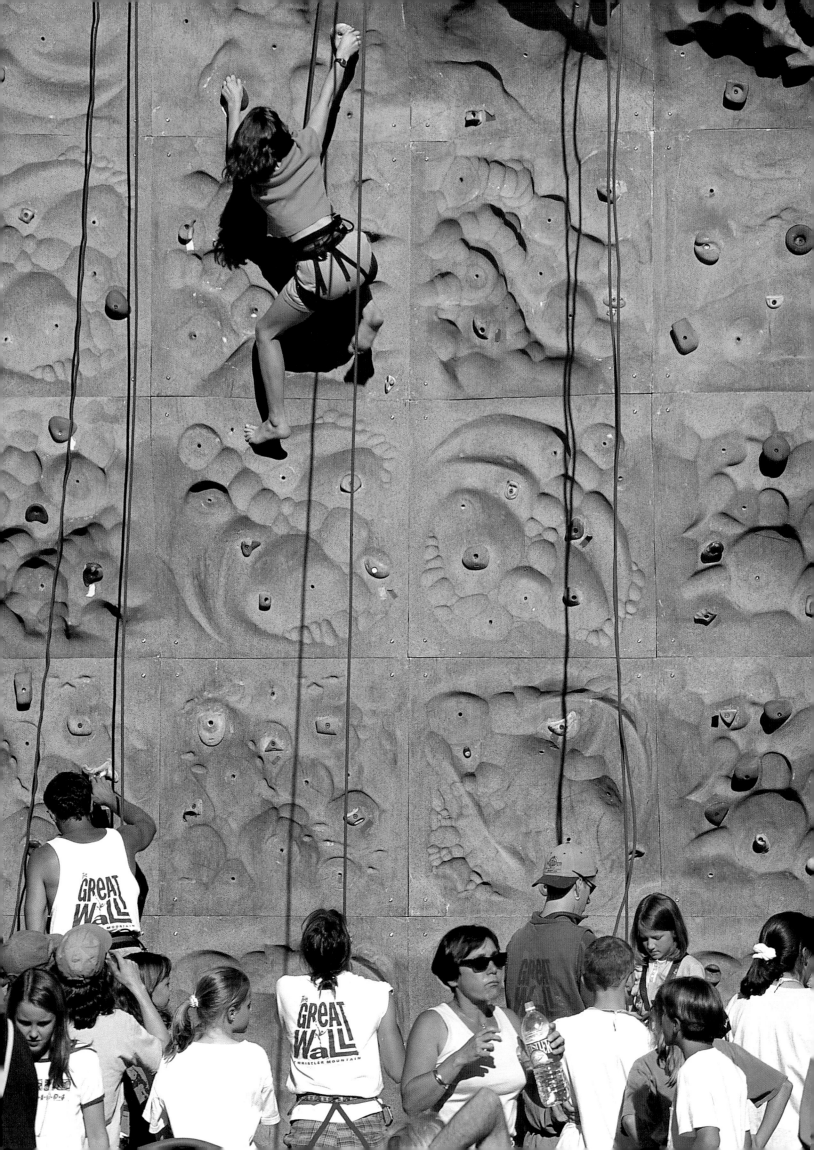

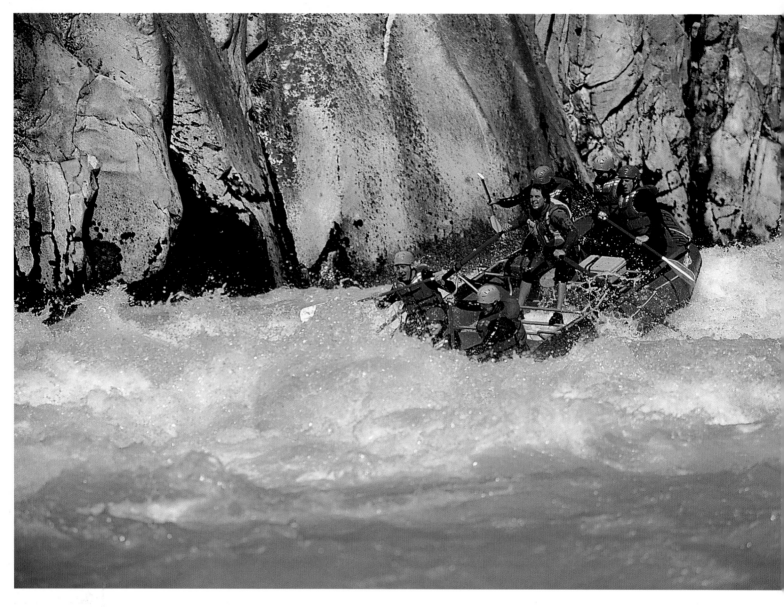

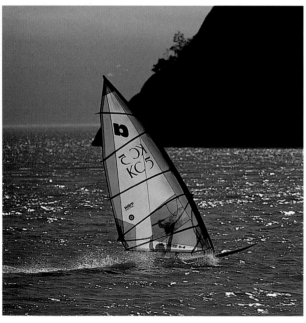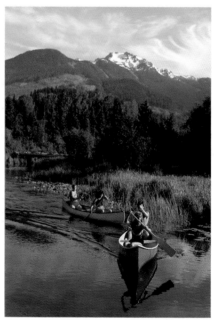

Top: Whitewater rafting on the Squamish River. Photo: Greg Griffith

Above left: Windsurfing on Howe Sound. Photo: Greg Griffith

Above middle: Canoeing on the River of Golden Dreams with Whistler Mountain in the background.
Photo: Greg Griffith

Above right: Lost Lake, a popular swimming lake close to Whistler Village. Photo: Paul Morrison

Opposite:
A kayaker enjoys a wild ride
on Callaghan Creek.
Photo: Paul Morrison

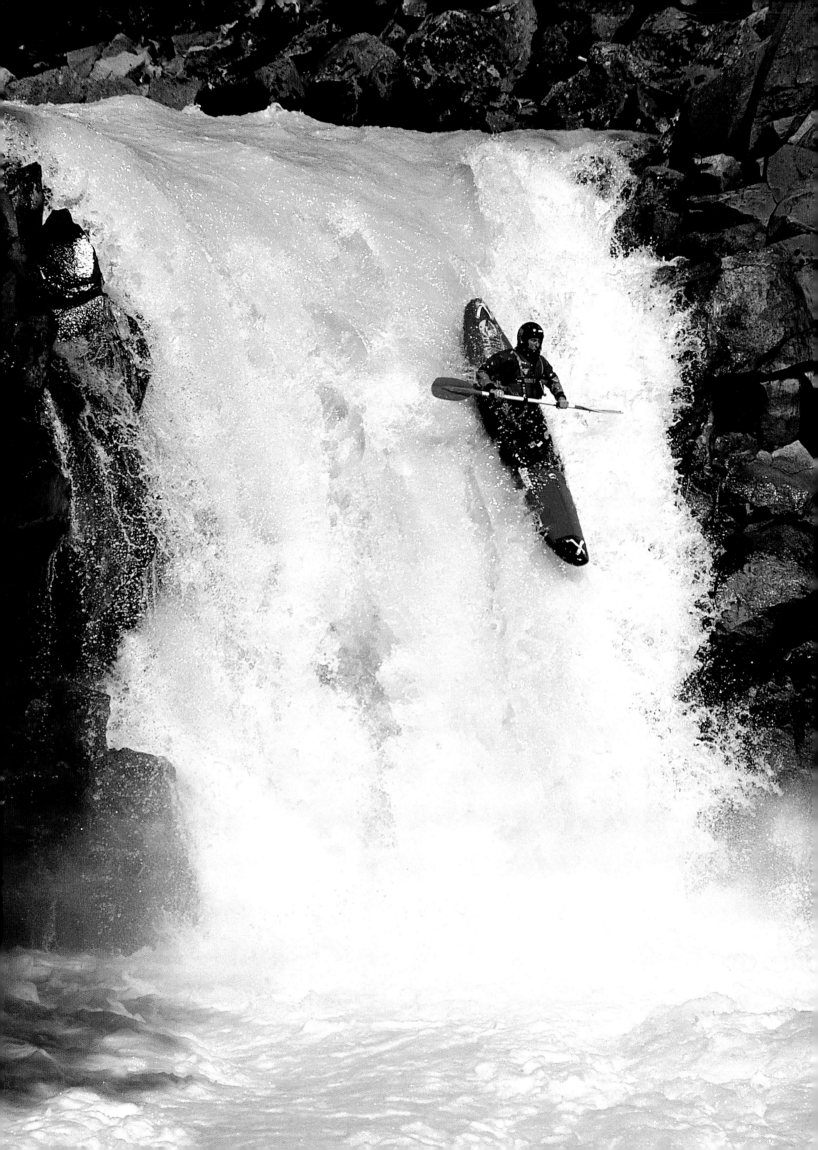

*Enjoying the Vancouver Symphony Orchestra high among
towering mountains, with a spectacular panorama
spread out below, is truly an inspiring experience.
Photo: C. Speedie-WRA*

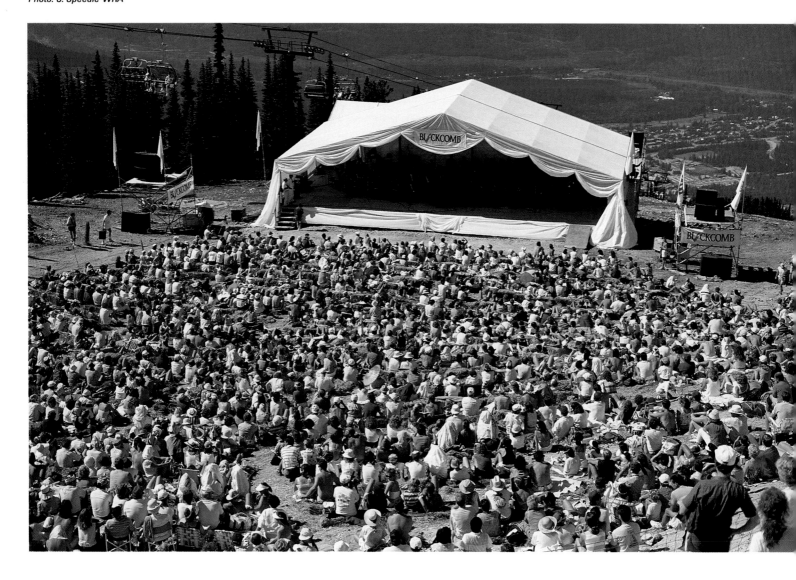

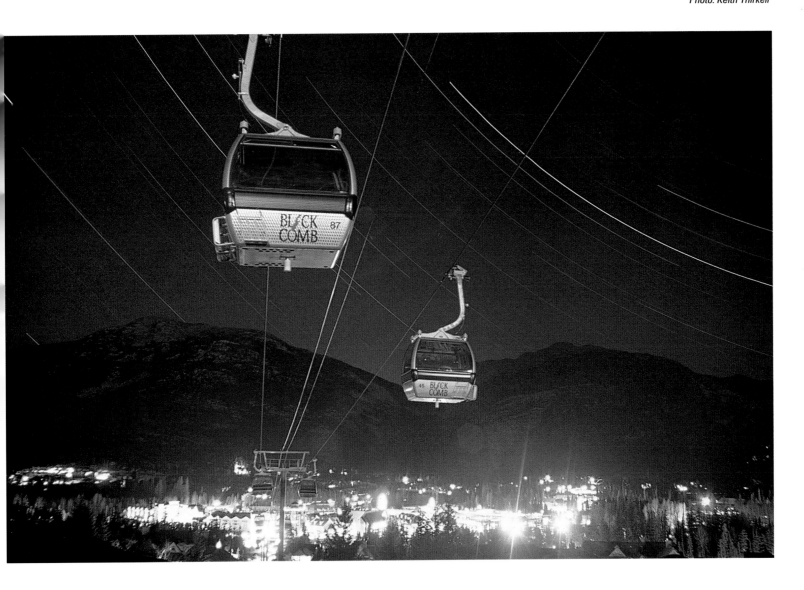

*Whistler Village at night, taken from
the Blackcomb Gondola.*
Photo: Keith Thirkell

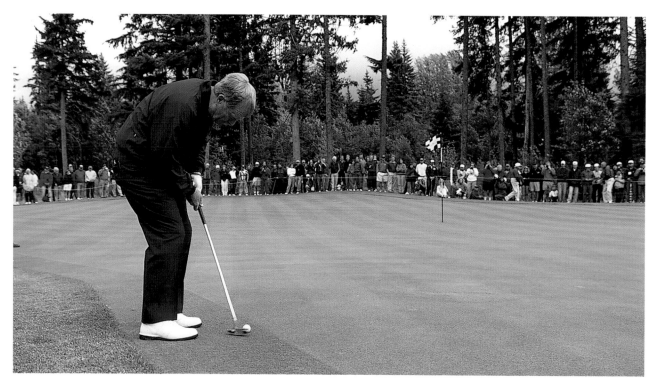

Jack Nicklaus putts at Nicklaus North Golf Course.
Photo: Greg Griffith

Below:
Aerial view of Whistler Village.
Photo: Bonny Makarewicz

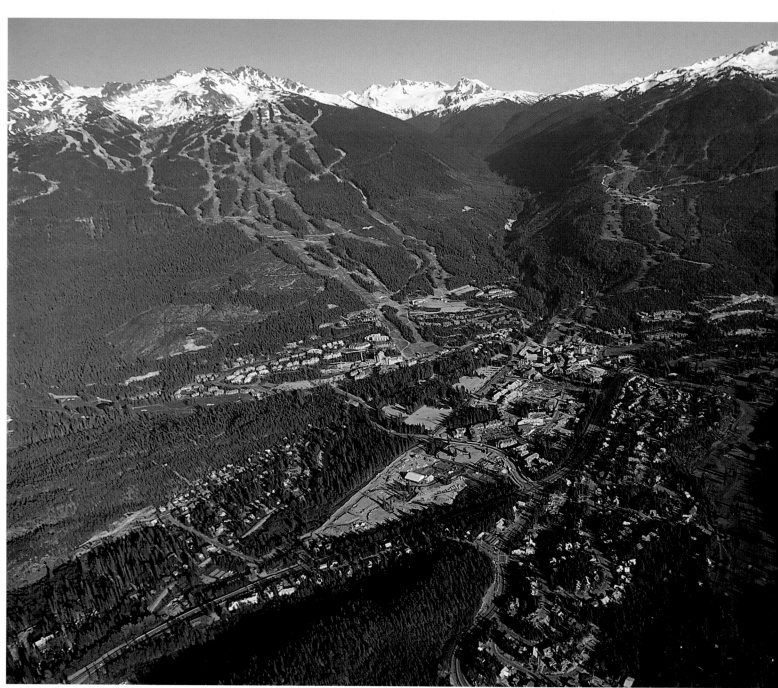

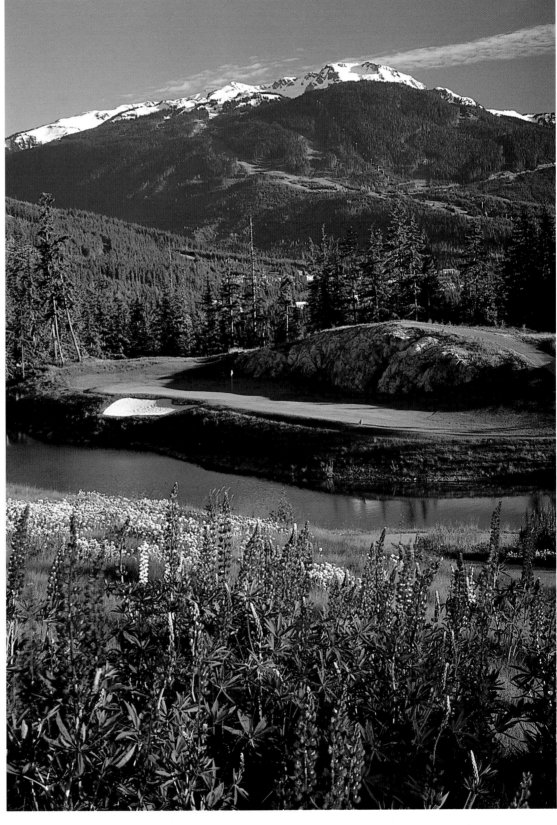

Chateau Whistler Resort golf course with purple lupine flowers in the foreground and Whistler Mountain towering in the background.
Photo: Brad Kasselman/Coast Mountain Photography

Parapenting has become a popular event on the slopes of Blackcomb Mountain.
Photos: B. Smith (left), Paul Morrison (right).

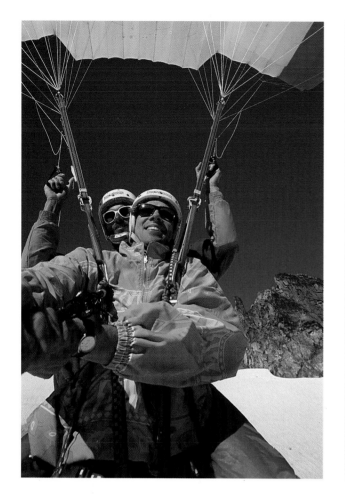

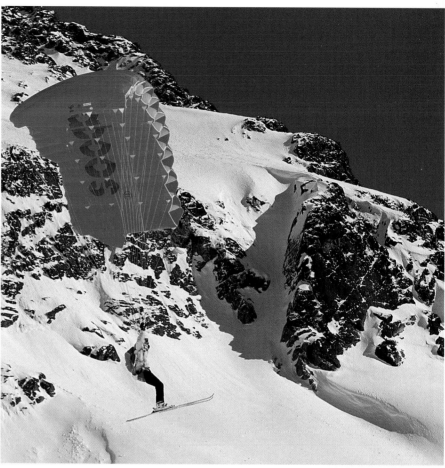

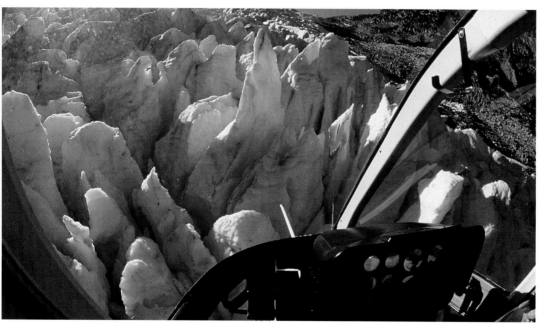

Flying over Tremor Glacier in a helicopter can be quite an exhilarating experience.
Photo: R. Grange-WRA

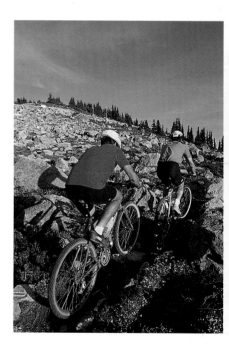

Mountain biking opportunities abound in Sea to Sky Country.
Photo: Leanna Rathkelly

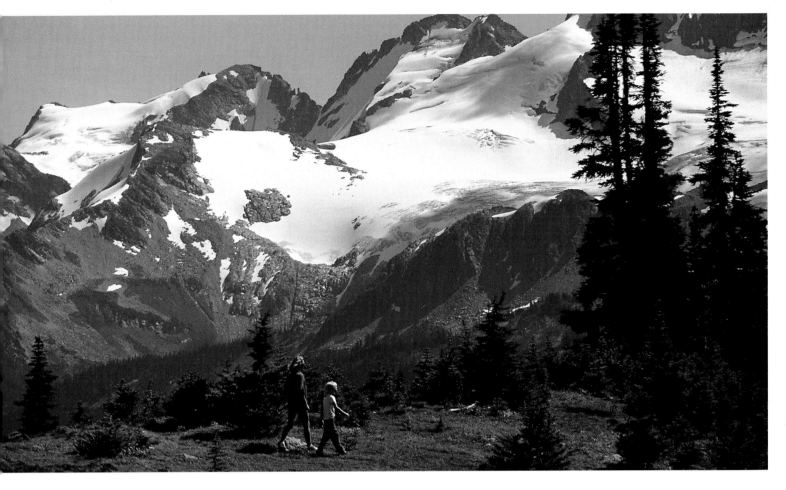

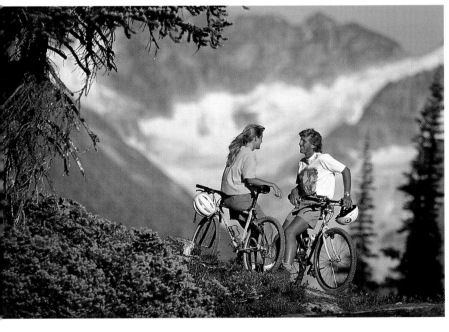

Thanks to the high-speed lift systems of Whistler and Blackcomb, outdoor enthusiasts can enjoy hiking and mountain biking in a magnificent alpine world.
Photos: Greg Griffith (top), Paul Morrison (bottom left).

Summer camp coaches ham it up for the camera on Whistler Mountain.
Photo: Paul Morrison

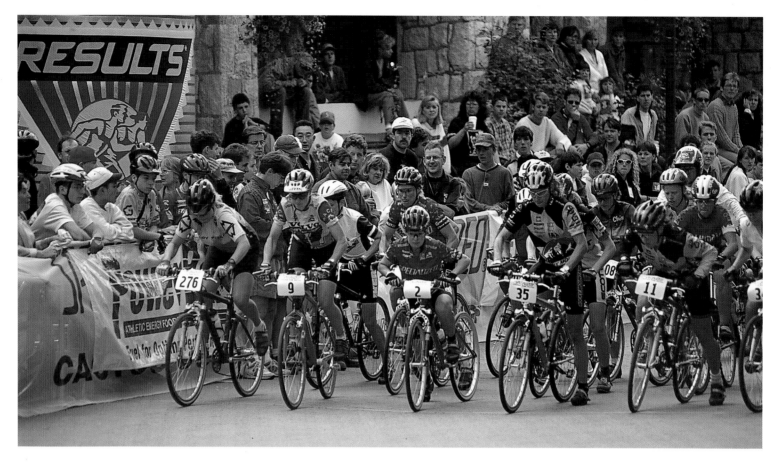

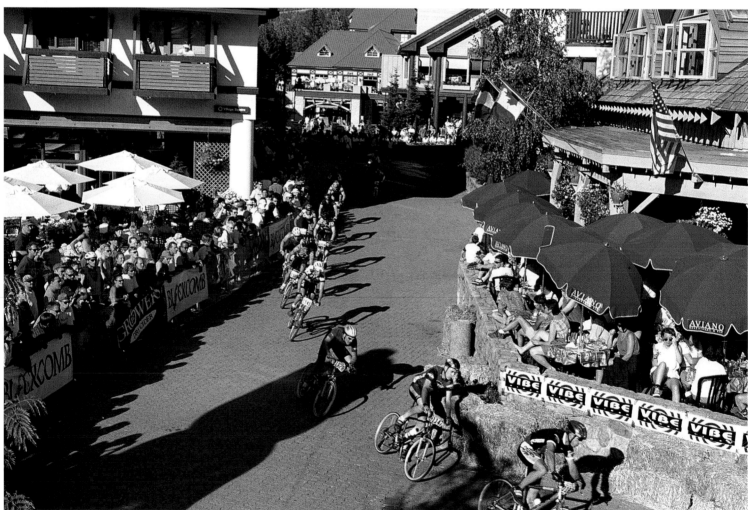

Top: Women Pro-elite riders line up for the start of the
Cactus Cup Fat Boy Criterion in Whistler Village.

Bottom: Riders make their way through Whister Village.
Photos: Bonny Makarewicz

Opposite:
Simbal Wells rides the Made in Shade trail
at Squamish.
Photo: Bonny Makarewicz

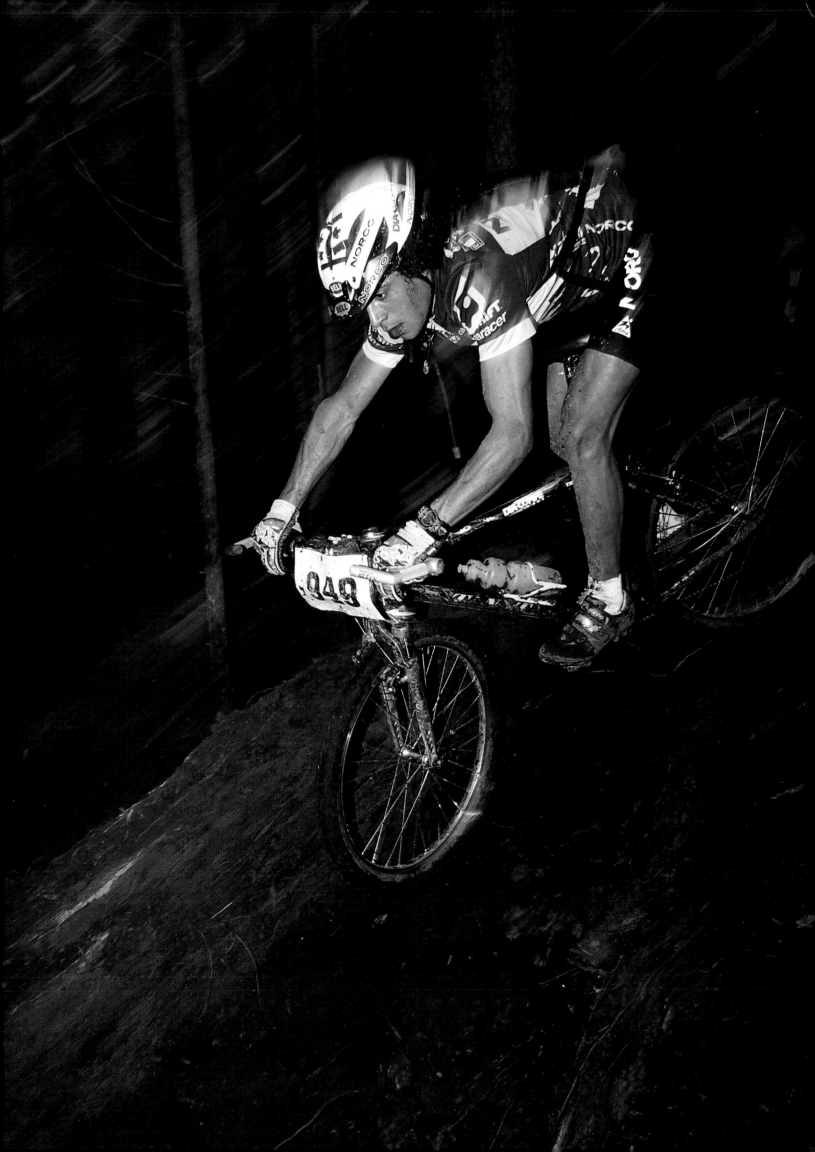

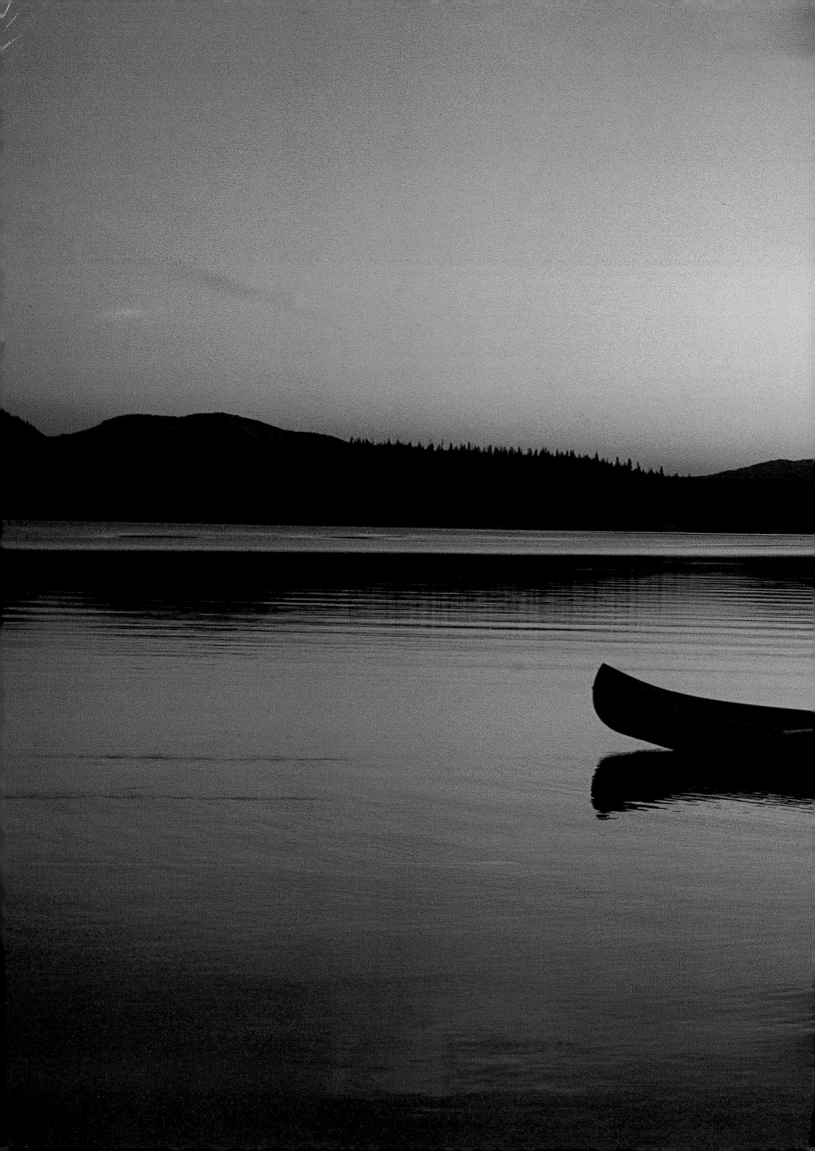

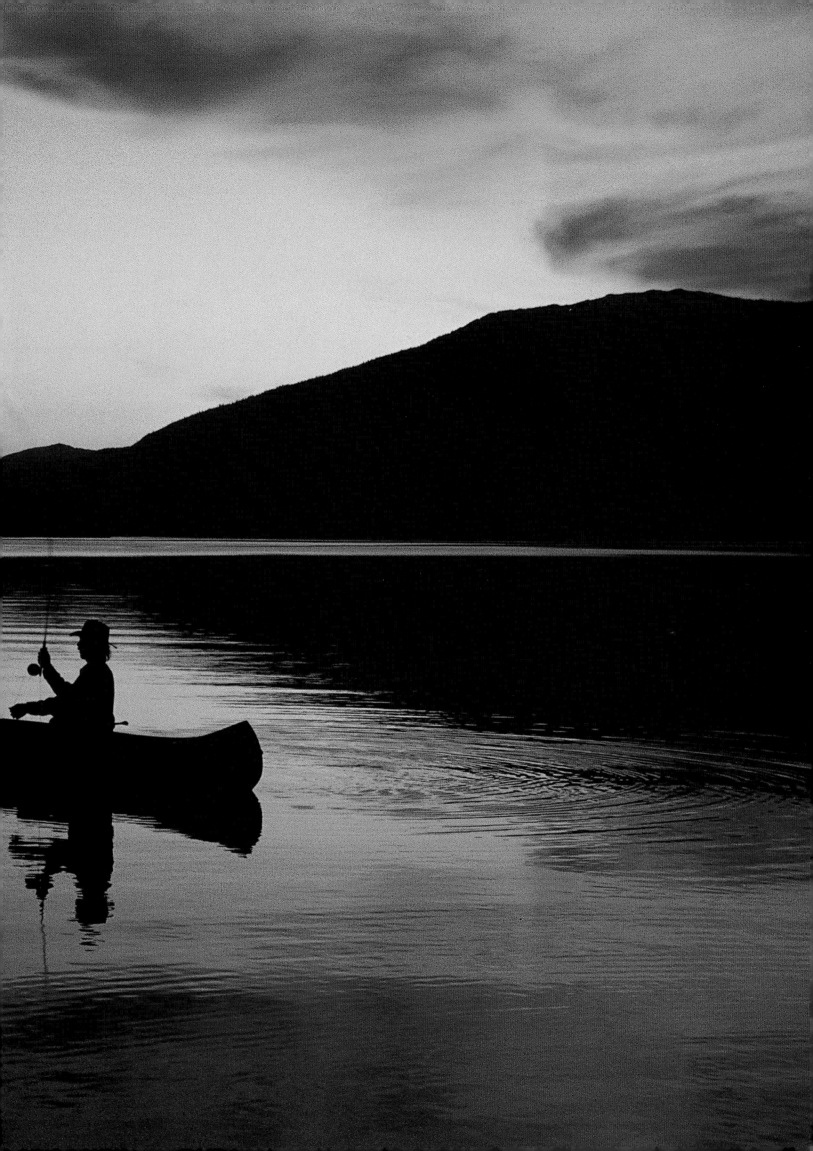

Previous pages:
Fly fishing on tranquil
Callaghan Lake.
Photo: Ingrid Wypkema

Right:
As winter approaches,
the trees change colour.
Photo: Paul Morrison

Below:
Sunrise reveals a slight dusting
of snow on Wedge Mountain, as
seen from Rainbow Lake.
Photo: Paul Morrison

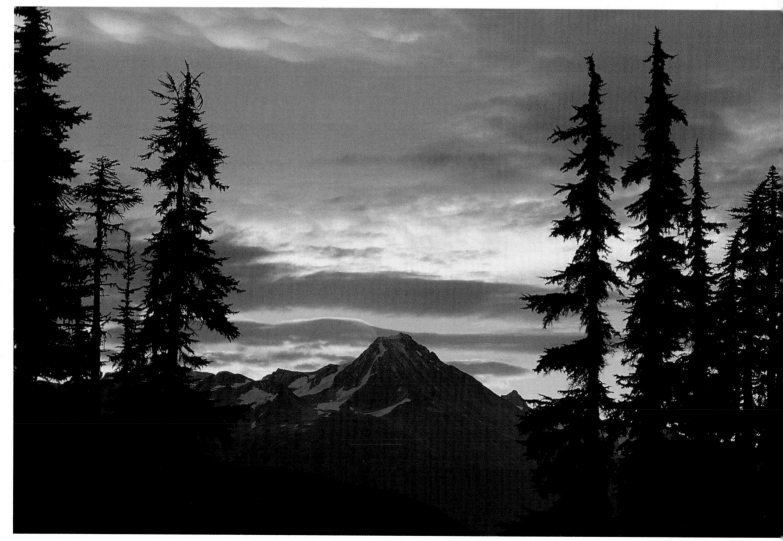

Opposite:
A visitor enjoys majestic Brandywine Falls.
Photo: Paul Morrison

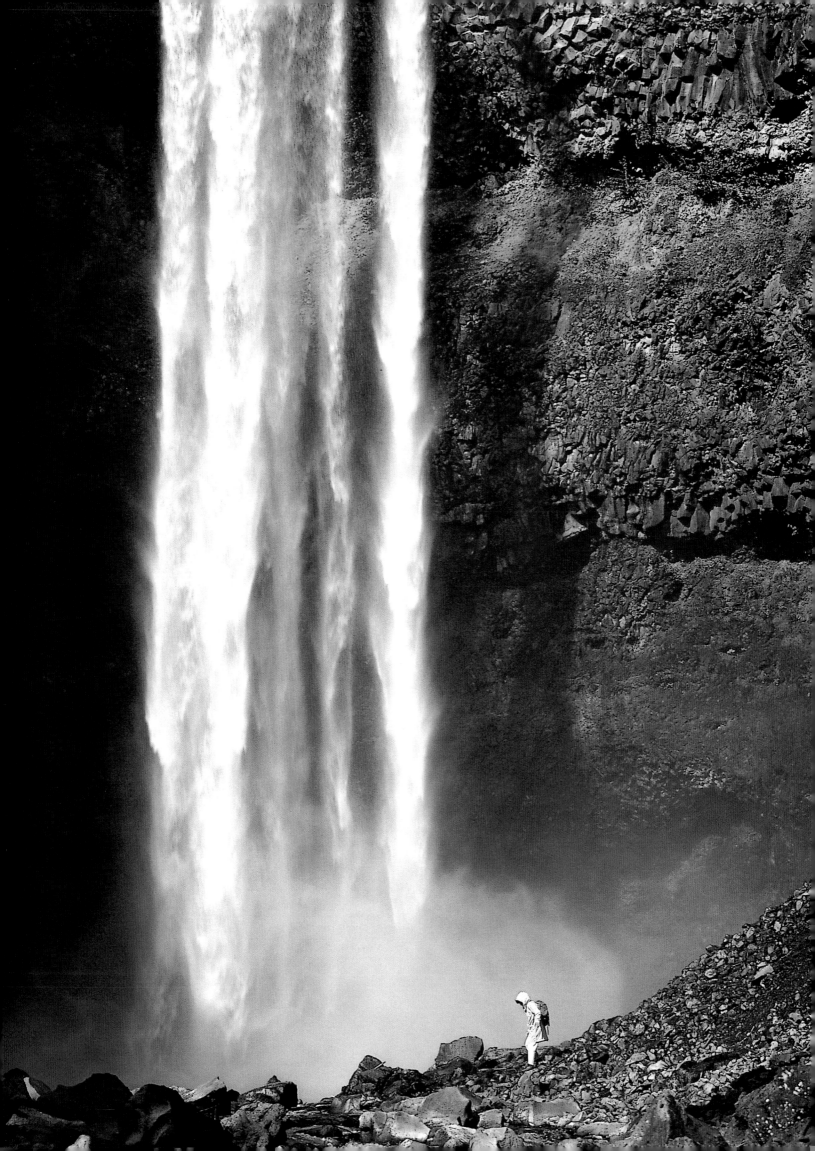

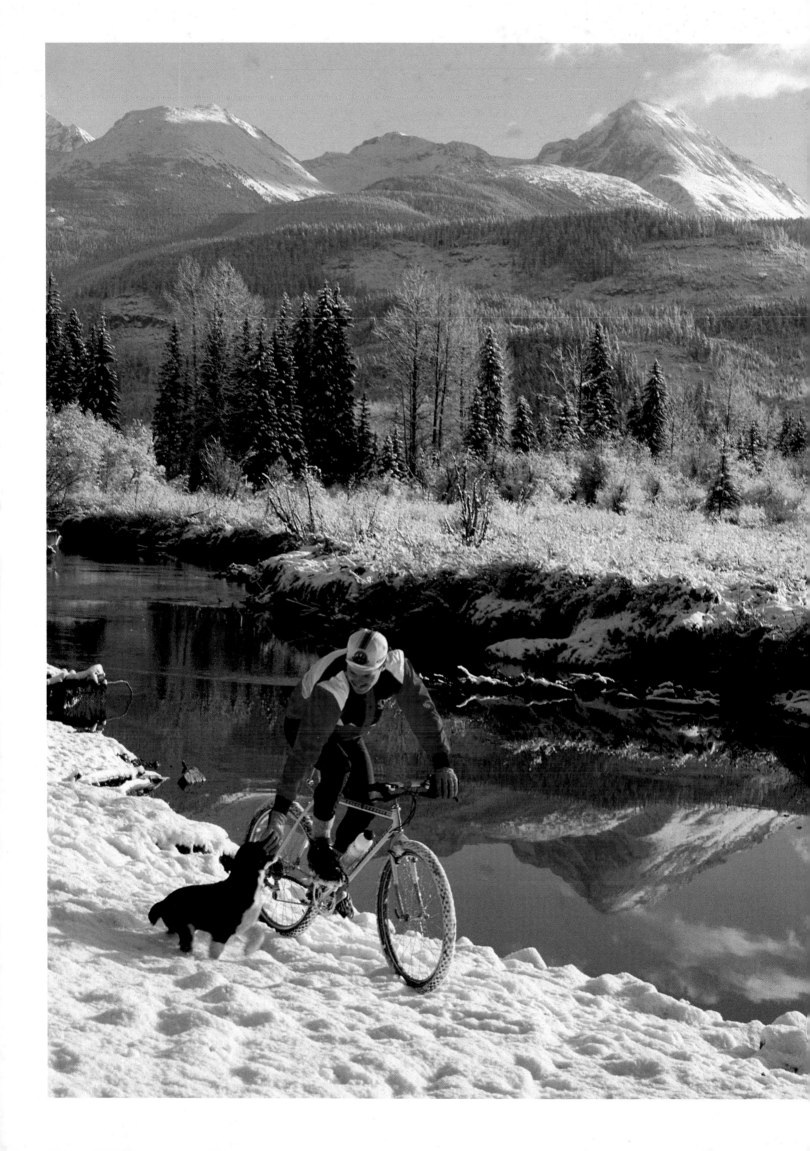